the busy girl's guide to digital photography ♥

the busy girl's guide to digital photography

lorna yabsley

D&C

David and Charles

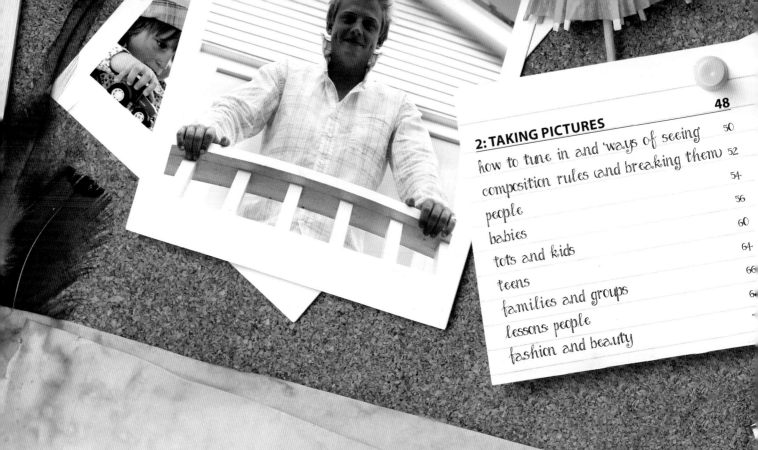

contents

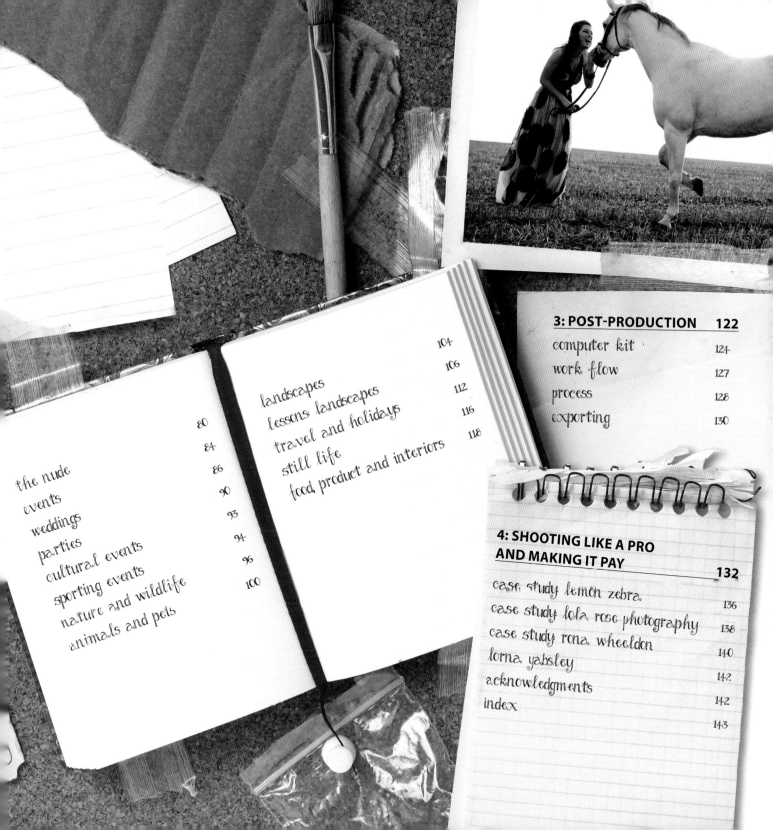

hello...

Dear Busy girl,

Hi, my name is Lorna. This is me, at work in my business, Bang Wallop. I have written this book to appeal to all you brilliant 'busy girl' creatives out there who are grappling with getting their photography right. Photography can be a man's world sometimes. Much of what is written and published about photography is very male-orientated, so I thought it was about time that we girls had something just for us. We all know men are from Mars and women are from Venus.

Joking aside, I do think men and women, boys and girls have a very different approach to learning, so this book has a female slant, with all the nerdy elements tidied away.

I have been a professional, jobbing photographer for thirty years (I started very young and am now getting on a bit!). I get my fair share of glamorous, high-end shoots but I am equally prepared to shoot a catering pack of soup, if it pays the bills, which it does. I never attended college, am a confirmed technophobe so a strange career choice perhaps. I didn't so much choose photography - I went to have my picture taken, fell in love with the photographer and learned the hard way (you can read my blurb and blog for the low down if you're interested). But I want to get on and teach you the best way to get to grips with your photography.

Whether you're a seasoned shooter or a total beginner, it's my aim to guide and mentor you through the process towards becoming an accomplished and rounded image-maker getting you off auto and putting you firmly in control of your camera. In this way, you will be freed to be creative, through composition, shooting and on to basic post-production techniques.

I hope you enjoy the book
All the best

Lorna
♡

the studio @ bang wallop

me now

the bar @ bang wallop

a much younger me with
my first proper camera

the gallery @
bang wallop

introduction

I love photography, I love looking at pictures and I love the creative process and making an image work: recognizing and seeing the appeal in the subject, the arrangement of shapes and light, mentally framing it, then capturing it – it's hugely rewarding. It's the technology I hate. Hate is perhaps too strong a word – I resist it, I am frankly bored and a bit baffled by it. Really, how many of us understand what all the buttons mean on our TV remote? What we really want is one with on/off, volume control and a channel selector.

'lovely motor!'

I can drive a car (actually I fancy myself as a bit of a rally driver) but I have little real idea of how the engine works. Likewise, although my camera has GPS and a multitude of other incredible capabilities, I have no real desire or need to use them all. Unless you're a bit of a girl-geek (chic of course) it's so overcomplicated; the sheer choice of cameras, the bewildering array of settings, functions and menus, and not forgetting the computer, and the advanced image-handling software… It's no wonder that from a beginner's perspective, it's enough to make you want to give up trying to figure it out and just stick the camera on auto and live with the compromise.

It's the age-old thing of knowing which are the right questions to ask, and understanding only what you *need* to know. In this book I aim to get to the kernel of key information, fast-tracking you to a better way and, dare I say, a more intelligent approach to shooting.

Throughout the book we will be looking closely at each aspect of photography; breaking it down into bite-size segments, from the basic functioning of the camera to understanding the settings and ultimately joining it all up, so you are in control of your image making. We will look at developing your 'eye' and the principals of composition in relation to the subject matter, as well as getting some basic post-production knowledge under our belts. Let's face it, with digital photography, unless you want a computer crammed full of image files that never get seen or shared, you are going to need to get to grips with the post-production process. It's now an integral part of becoming a well-rounded, competent and creative photographer.

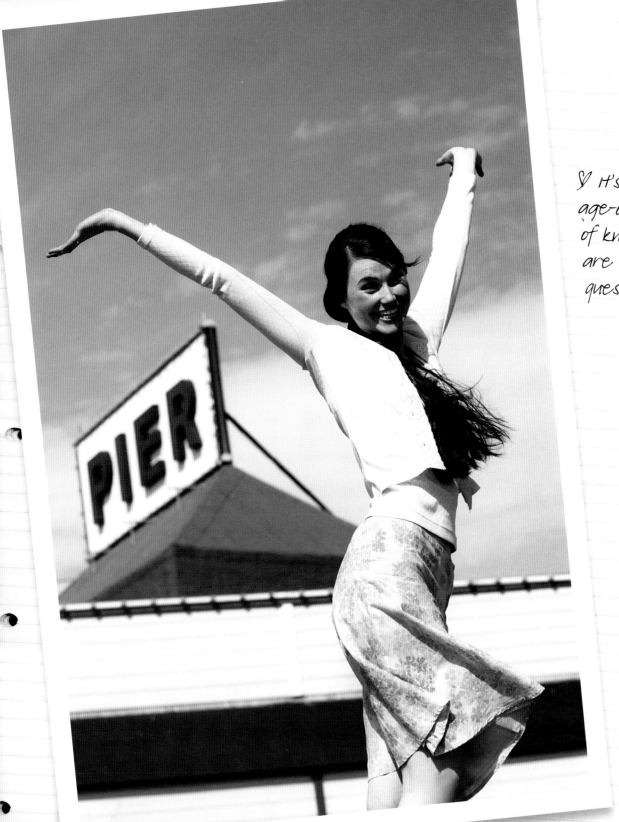

♥ It's the age-old thing of knowing which are the right questions to ask

THE RIGHT ANGLE

It was the bold red sign that caught my eye at first, then it was a matter of balancing the model on top of a rubbish bin, with me on a wall ensuring that all the clutter at ground level was not in frame.
120mm f5.6 1000th sec
ISO 100

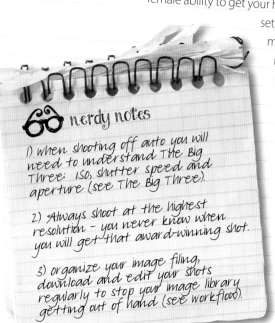

"I'm ready for my histogram doctor!"

So you are the proud owner of a cool digital camera and the instruction manual (yawn). You've bought the 'How To' book, but frankly you're still baffled.

You can see the shot, you know how you want it to look, but somehow it just isn't coming out the way you want it to. You've even gone online and done a few tutorials. You've had some success and achieved some really good shots, but you got there more by luck than judgement. The manual you've read is *soooo* boring, it's talking 'histograms' and you're only on page six!

So, what do you do? Revert back to auto or worse still, your camera phone? You've lost the manual to the drawer that contains random phone chargers and the book is on the shelf along with *Fifty Shades*. Your photography is going nowhere. That's because you're back on auto and your camera is in control. If you want to take control (and I don't know a busy girl who doesn't) and become the creative photographer that you know you're capable of being then you will need to understand the basic principals of photography and how your camera works. In order to become accomplished at this, we are going to have to get real and the tech stuff does need to be explained to a greater or lesser degree.

Throughout the book you will see the 'chic geek' specs symbol, this indicates my Nerdy Notes and these will give you a succinct technical explanation. I find it helps when reading these to talk through your nose 'nerdy-style'. The Top Tips are designed to give you some interesting facts, useful hints and shortcuts, to fast-track you through the learning experience. For good measure there are also a few stories along the way, to stop it from becoming too dull!

Luckily we are famed for our busy girl multi-tasking skills, and you will need to use this amazing female ability to get your head around shooting off auto and on to the semi or fully manual settings. I ask you as your mentor and guide to work through each section methodically and really grasp the basics before tackling the next stage. It may seem disjointed and irrelevant, but you will get to the end of each section with a Ta Dah! Ultimately you'll arrive at your EUREKA! moment, when it all comes together. You *will* need to practice – just like learning to drive it all feels very alien at first – but the beauty of digital photography is that you get your feedback instantly, and you will learn very quickly how to control your exposures, giving you creative control over your image making.

nerdy notes

1) When shooting off auto you will need to understand The Big Three: ISO, shutter speed and aperture (see The Big Three).

2) Always shoot at the highest resolution – you never know when you will get that award-winning shot.

3) organize your image filing, download and edit your shots regularly to stop your image library getting out of hand (see workflow).

eureka!

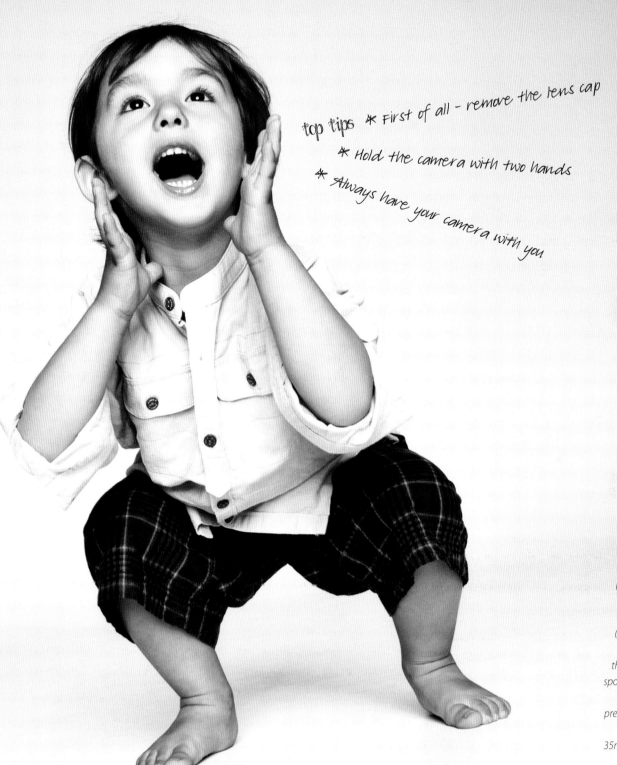

top tips ✲ First of all – remove the lens cap

✲ Hold the camera with two hands

✲ Always have your camera with you

BOY CALLING

*Whenever and wherever
I photograph children,
I am usually down on the
floor with them, letting
them do their own thing
(within reason). Often it is
the very first few minutes
that will give you the most
spontaneous shots; so make
sure you have everything
pre-framed and set correctly
for the action to unfold.
35mm f11 125th sec ISO 200*

1: learning to drive your camera

Photography has never been more popular; now everyone is a photographer thanks to smart phones, intelligent auto exposure, auto focus and all the rest. Technology has made better photographers of us all, and for most users, it's enough to shoot on auto settings most of the time. But it is a misconception to think that digital is easier. Certainly it has made photography more accessible, but for those of us who want to take our image making to the next level, staying on auto really is not an option. Unless you are driving your camera, it will be driving you!

Throughout this section I will guide you, step-by-step through the basic photographic principles, looking at the different types of cameras and lenses, how they work and what they do. We will also look at file types, image quality, modes and functions, your histogram, your exposure compensation button and much more. This key foundation knowledge will put you in control and give you the relevant understanding of how to get the most out of your camera gear, with the ultimate aim of making you a better photographer.

First and foremost, you must understand the basic principles of photography and then, in turn, your camera and its settings. *You* must be the one in control of exposure. It is not enough to turn the dial to auto and snap away in the hope that you will capture all your images in the way you want.

The vast majority of people do resort to using auto on their cameras. Equipment is now so sophisticated and 'intelligent' that incredible exposure accuracy can be achieved this way, and while there is no shame in shooting on auto, there will be some occasions when your camera won't be able to read and interpret the scene as you would like. Ultimately if you want creative control in your work then you need to fully understand the basics of making an exposure. Like learning to drive it's not difficult or complicated once you know how it's done. The camera is an instrument, and to become an accomplished player you will have to practise.

So engage your busy girl multi-tasking skills and be prepared to 'pat your head and rub your tummy'. And remember: you don't have to be a technical mastermind to be a brilliant photographer.

SNAPPERS SNAPPED
You need to be bold sometimes to achieve the shot. I popped up in front of this group of happy snappers to snap them, ruining their shot but getting mine. With charm, humour and timing you can get away with it. 35mm f8 80th sec ISO 400

top tip

* getting off auto and shooting manually or semi-manually is a giant leap – from the camera controlling everything you do, to you controlling your camera

what is photography?

To really get to grips with your image making, I think it's important to understand the actual organic process of how an image is captured. When we press the button and 'take the picture', we completely take it for granted and don't stop to consider the miracle that takes place. Ask the question… what is photography?

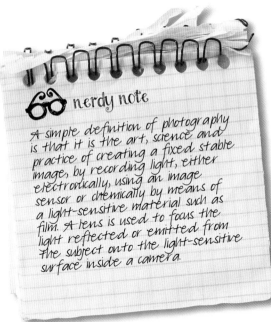

Early image projections were made using a *camera obscura* from the Latin words meaning 'darkened room'. The first record of the *camera obscura* principle goes back to Ancient Greece, when Aristotle noticed how light passing through a small hole into a darkened room produced an image on the wall opposite, during a partial eclipse of the sun. However, an understanding of the principle may be much older than that. Stone-age man may have used the principle of the *camera obscura* to produce the world's first art in cave drawings. And most famously the renaissance artists used them to paint near photographic likenesses.

I created a room-sized *camera obscura* of my own once. When I first started out as a photographer and was 'living over the shop' in an old studio, in a windowless old warehouse, I found I could project the outside world onto my white duvet cover via a small shaft of light through a tiny hole in the roof. I was literally living and breathing photography! It's a pretty simple procedure to replicate yourself, if you find yourself with nothing better to do (I know, very unlikely, but if you are interested…), and to illustrate my point, follow the instructions below and make your own *camera obscura*.

camera obscura - living and breathing photography

Shut out all the light from a room by covering the window with a piece of card or hardboard, cut to fit. Bore a small hole through the card or board. An upside down image of the scene outside will appear on a piece of paper held opposite the hole.

A portable camera obscura can be made out of a cardboard box. First, tape up the box to ensure that no light can penetrate it. Then cut away part of one end of the box and fix a screen of tracing paper across it. At the opposite end cut a hole in the box, cover this with foil, tape down the edges and bore a neat round hole through the foil that is no larger than the lead of a pencil. Take the box outside, or to a window, shutting out as much light as possible by putting a thick blanket over your head. An upside down image of the scene outside will be seen on the screen.

To make an even clearer image, use a small piece of tin, a drinks can is ideal. Pierce a hole with a pin, sand down the edges of the hole on each side with fine grade sandpaper or a nail file. This will give a very fine smooth aperture (to be explained later) and the resulting image will be sharper.

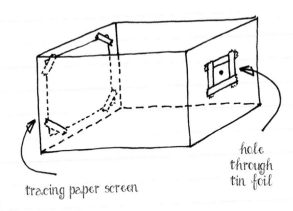

tracing paper screen

hole through tin foil

what is a camera?

In its simplest form, it's the pinhole camera, much the same as the *camera obscura*, that is to say, a light-tight box with a pinhole in one end, but with a piece of film or photographic paper secured at the other end. Right at the other end of the spectrum, we now have highly sophisticated mirror-less compact system cameras, digital SLRs, and digital backs for medium to larger format cameras, all capable of extraordinary image capture.

There has been a quantum leap, and it's almost impossible to keep up with the rapid advances. It's easy to think you have to have the very latest thing, but most cameras work perfectly well, so don't get hung up about it. Just use the camera you have and get on with enjoying your creative image making.

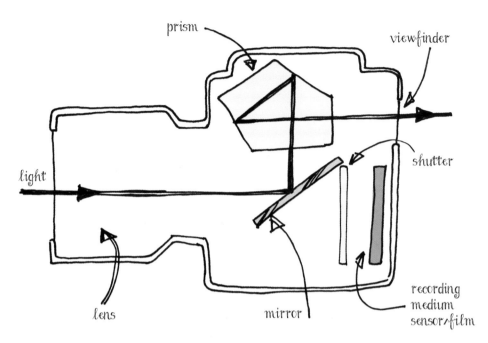

In the last 100 years or so, advances in cameras and film have brought photography to the masses, starting with the Brownie. This simple and very inexpensive box camera introduced the concept of the 'snapshot', but it was the development of the Leica that really heralded the first compact, using 35mm film. After that the Nikon F series was developed, an SLR (single lens reflex), allowing the photographer to view at eye level what the camera was 'seeing', using a prism head and mirror. This was really the first system camera to have a range of interchangeable lenses and accessories.

But some things don't change. The person behind the camera will always be the most important element in photography.

Eons ago, in the 'olden days' when we all shot on film (actually only about 12 years ago), image quality was truly governed by the quality of the optics in the lens, the

film quality and ultimately the processing of the film and final print. Now with digital photography, image quality is governed by the sensor type and size, the lens, the quality of the camera's processor, digital post-production and ultimately the print process.

Early DSLRs (digital single lens reflex) required you to take out a small mortgage in order to afford one, plus quality was an issue and they were pretty unforgiving. The modern digital camera on the other hand is really an incredibly powerful computer, with menus and options to drive all the functions from the camera body. It replaces and makes redundant the simpler mechanical operations of a film camera, where the only electronic part was a battery to run the light meter (and *that* was sophisticated...). I miss the reassuring *click click* of adjusting the f-stop aperture settings on my lens manually.

the film v digital debate

Also, let's not forget the fundamental difference between film and digital. There are many people who still shoot film, I do on occasion. It's hard to beat the quality of film, and for purists it still has the edge over digital. Certainly that has been true for the lower budget, smaller and earlier generation of digital cameras, but as technology advances, in some instances – shoot me down in flames! – digital has superseded the quality of film. Undoubtedly there is a subtle difference between the two, much like that between music on CD and vinyl, but really there are so many other factors that need to be considered in this film versus digital debate, such as post-production of the image file, print type and quality. My feeling is does it really matter? As long as the quality is 'there' then surely it has to be, first and foremost, about the content and composition of the image itself.

OLD AND NEW

I shot the vintage cameras on my pocket snapper at the market. It's incongruous seeing the old technology instantly appear on the new. It is phenomenal how quickly technology has advanced.

types of camera

As if learning how to use a camera wasn't confusing enough, there are literally hundreds of models of each type of camera, all with scary sounding names like D3Xs or ZDB (actually I am not sure if that isn't a type of car), and keeping up with the new and improved versions coming out every day can be totally baffling.

Take comfort: it will surprise you to know that actually there are in the main, really only seven different types of camera (unless you add the obscure and enthusiast's specialist gear, in which case there are a few more, but let's not go there). As a novice you will probably only concern yourself with the compact systems, bridge and DSLR types, and possibly a rangefinder if you turn out to be a purist and incredibly cool and hip and into your Leicas. I hope knowing that there are really only seven, makes it all a little less daunting to get your head around.

So… which one are you?

smart phone *Now available with zoom capability add-ons, and improved sensors for superior quality, amazing image enhancing apps, combined with instant sharing. What's not to love about this ultra-convenient ultra-compact? I use mine all the time and really enjoy it.*

bridge *A bigger camera with an attached, non inter-changeable zoom lens, it has the look and feel of a DSLR (see DSLR) with an EVF (electronic viewfinder). It's cheaper and usually slightly smaller than a DSLR. These cameras generally give you some or complete manual control.*

compact *The one we are all familiar with. It has dominated the market place for years: a real favourite, small and easy to carry around, a camera that you will always have with you. Hundreds of models are available, however, statistics show that compact camera sales are in sharp decline with the advent of the smart phone.*

rangefinder *Slightly larger than a compact camera, but still very easy to carry around. The first high-quality compact systems were rangefinders and they generally have superb prime lenses. However, the viewfinder does not show exactly how the image is framed. Really only for purists.*

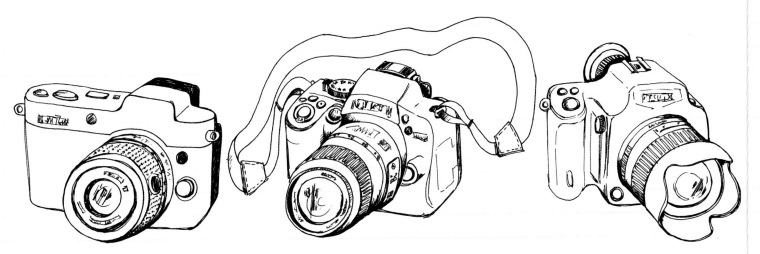

mirrorless systems *The newest generation compact system cameras, even though they are compact they can house the larger full frame sensors, as found in the ever popular DSLRs. Compact because the mirror system found in the DSLR, that gives you the actual image through the viewfinder, has been removed, and an EVF electronic viewfinder is used instead, although this can make you feel less connected with your subject. Mirrorless systems have a full range of interchangeable lenses even though they are more compact – these little cameras are phenomenal – but as with all things compact, they are a little more fiddly to navigate around.*

DSLR *In a pre-digital age, these were simply SLRs – single lens reflex cameras. The design and functionality of these 35mm system cameras are so evolved that everyone knows what they look like: the familiar chunky camera body with a potential array of inter-changeable lenses. They are the pro's choice for workhorse system cameras: bigger than a compact, but still portable. Looking through the viewfinder, you see your actual subject as seen through your lens, via the mirrors in the prism head. You can fully engage and connect with the subject. Focusing and framing your image is easier, quicker and more precise than other systems. Small is beautiful and these cameras with all the kit can be heavy and bulky, but the newer generation DSLRs are very compact, and if you are serious about your photography, then these are great cameras to use and certainly the best to learn on.*

medium format and large format *These are bigger, more serious cameras. They have much bigger sensors, or have bigger film sizes, compared to a standard 35mm, and give beautiful quality and detail. Larger frame medium format cameras generally start at 6x4.5in, to the familiar 120mm square format so popular with professionals, with lots of alternative sizes depending on make and model. Then you come to the large format cameras, where we jump back into the 'olden days' with not a metric measurement in sight, with familiar sizes such as 5x4in and the universally popular 10x8in. These are also known as field cameras, the ones where you definitely need a tripod and a big black cloth to stick over your head so you can see the image you are shooting clearly projected onto the glass ground screen. These cameras are still used for high-end commercial shoots and by fine art photographers, but you could contend that the advantages of superior quality (because of the sheer size of the image capture) is now outweighed, as they fall more and more out of favour as technology advances.*

lenses explained

Your camera phone, basic compact and bridge cameras will all have lenses that are attached as an integral part of the camera's main body. Generally most models will have a zoom capability, giving you a range of focal lengths to change your view from a wide-angle at one end of the scale, to telephoto at the other end, enabling you to shoot a subject in the distance. Often this telephoto range is extended by incorporating a 'digital zoom' that effectively enlarges one area of the image; this does however affect the quality. System cameras, such as DSLRs and compact system cameras, have detachable lenses. There is a huge range and generally speaking the more you spend, the better the quality and versatility.

We have tackled the confusing array of different camera types and now we must face in much the same way, the baffling choice of different lenses. Again, take heart, it's not as complicated as it first seems. Camera lenses come as either 'zooms', which cover a range of focal lengths, or 'prime' lenses, which are fixed at one focal length. Additionally there are specialist lenses such as macros and super telephotos.

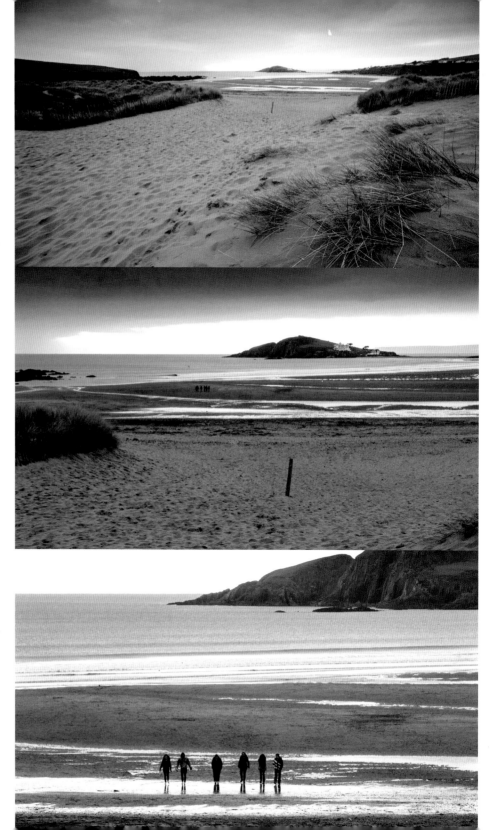

prime

Prime lenses are fixed at only one particular focal length, in other words they do not zoom in and out. They come in every conceivable focal length from fish-eye wide to super telephoto. The advantage is that the lens is less complex than a zoom and therefore has less glass within the workings, so the quality is usually very good. Also, because the light has less glass optics to travel through, they are good at recording in low light conditions, and they generally have a broader aperture range (see Specialist Lenses and Aperture, explained later). The disadvantage is that you would need to carry a lot of lenses to give you the full range that a single zoom lens can offer.

ONE SCENE, THREE LENSES

These three shots illustrate the same scene shot on wide, mid range and telephoto lens.

Wide 14mm f10 50th sec ISO 400

A wide lens offers a very wide perspective taking in the foreground. Distant objects will appear much smaller than to the naked eye. Beware of distortion on the edge of your frame. Shallow depth of field (bokeh) is harder to achieve with a wide lens (see The Big Three for more about depth of field).

Mid range 50mm f10 50th sec ISO 400

This is closer to your eyes' natural field of vision. A prime 50mm lens is often included when you buy a DSLR, and although you may prefer the versatility of a zoom, it will always be a useful lens in your bag.

Telephoto 200mm f10 50th sec ISO 400

A telephoto (long) lens will bring far away objects nearer to you and will give a narrower field of view and foreshorten perspective. With more optics this is usually a heavier lens and less easy to hold steady in your hands. Take care that you select a higher shutterspeed to avoid blurred images. Shallow depth of field (bokeh) is easier to achieve with a long lens.

zoom

Zoom lenses are so convenient and versatile, giving you the option to shoot wide or zoom into the distance, but bear in mind that the lens design is hard, and with zooms in particular you lose quality in order to get range. Generally shorter range zooms include fewer compromises than long-range ones. With do-it-all lightweight lenses, with ambitious specification, quality is bound to be compromised. Here's a list of zoom lenses that you may come across:

wide-angle lenses Traditionally, a super wide-angle lens is classified as anything under 20mm. As a rule, a wide-angle is between 21 and 35mm.

standard lenses A standard lens has a focal length range of 35–70mm. The most common standard lens is a fixed prime 50mm lens. This is close to our eyes' natural

size matters?

field of vision and is often sold with the camera body as a starter lens.

Medium telephoto The focal range of between 80–135mm provided by these lenses is nearly always used by portrait photographers: a slightly longer lens is always more flattering as it fore-shortens slightly and is a good fit for head and shoulder framing.

WHICH LENS IS BEST?

Don't be tempted to buy one do-it-all, wide-to-telephoto lens unless you are spending a lot of money – invariably it won't perform. Instead buy a couple of good quality, faster, shorter range zooms (see What Gear to Buy). Don't be lazy; change and use different lenses to suit the composition and get the best results.

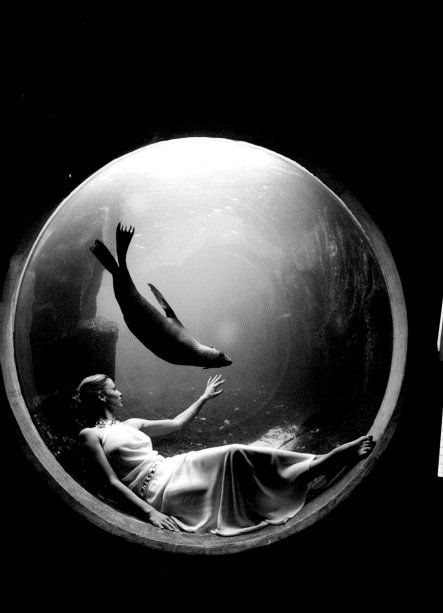

Telephoto Any lens with a focal length of between 135–300mm is a true telephoto lens. Telephoto lenses are traditionally used for sports and wildlife photography, but their essential function is to bring distant objects closer.

top tips

* when you buy a lens make sure it's compatible with your camera body. Nikon and Canon have different fittings; some older lenses may not work on newer bodies and vice versa

* keep your lenses clean. Be careful not to scratch the optics, particularly the rear element, where the lens connects to the camera body

* A standard 50mm lens is a close match to the human field of vision

* A telephoto lens will foreshorten perspective

* A wide-angle lens will distort on the edges of the frame

GIRL, GOWN, SEAL

On location at an aquarium, the concave viewing window was an obvious place to seat the model, the lighting is natural from the sky above so it was a very simple shot to achieve – apart from getting the seals into the shot and up close to the window. We tried everything from calling out to feeding them from above. Eventually we arrived at the solution: the model slid a piece of A4 paper up and down to engage them and I was able to get the shot; always keeping an eye on her position, how the all-important gown was looking, and making sure my exposure was correct. I selected a faster shutter speed to ensure the fast-moving seal's movement was frozen and sharp.

specialist lenses

As you progress with your photography, you will be beguiled and tempted by other pieces of kit. Beware of loading yourself down with unnecessary lenses, but if you get into a specialist area, you might need to splash out on one or more of the following:

Super telephoto These have a focal length of more than 300mm, and are used by dedicated sports and wildlife photographers.

Macro These lenses are able to focus closer to an object than normal lenses. Used for still-life photography of small objects.

Fisheye These are on the edge of wide-angle lenses, and give a distorted view of the subject matter. The centre of the image is magnified, and objects diminish in size in all directions around it.

Take care when you're removing and fitting lenses as dust can be attracted to the sensor and cause problems, especially on DSLRs without dust cleaning features. With the camera switched off and facing downwards, remove and replace lenses quickly. It's a bit fingers-and-thumbs at first, but it will become second nature the more practice you have.

nerdy notes

Lens jargon explained:

Fast lenses have the largest apertures, and will therefore let in more light – better for working in low light conditions, and giving soft shallow depth of field.

Sweet spot refers to the fact that all lenses will have an optimum setting, generally around the middle of the range f5.6 and f8. This is where the lens will produce the sharpest image.

IS means 'image stabilization', and uses gyros to steady the wobble, giving you greater control at lower shutter speeds – some camera bodies also have built in stabilizers.

bokeh is the area of image that appears soft and out of focus.

Sensor size The focal length of your lens is affected by the size of the camera's sensor. A full frame sensor will give you the focal length shown on the lens, a smaller sensor will extend the focal length. For example, a half frame sensor and a standard 50mm lens will increase the focal length to around 80mm, this can be useful when you want longer shots, but not if you want a wide shot.

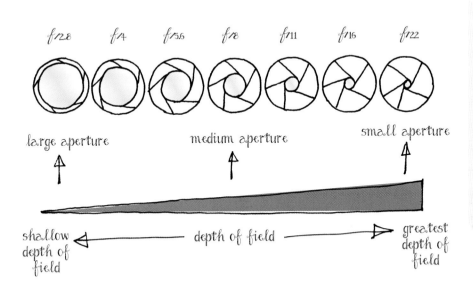

f/2.8 f/4 f/5.6 f/8 f/11 f/16 f/22

large aperture medium aperture small aperture

shallow depth of field depth of field greatest depth of field

APERTURE

Within the lens is the 'aperture', which is basically an adjustable hole, just like the iris of your eye. It controls the amount of light passing through the lens and onto the sensor in the camera's body. The aperture setting will affect the depth of field within your image (see The Big Three).

♥ Beware of loading yourself down with unnecessary kit

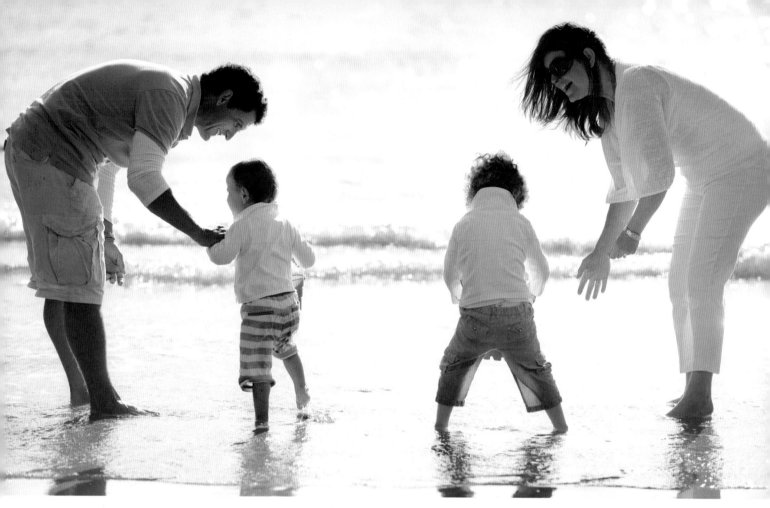

SPOT METERING

This strongly backlit subject was difficult to expose. Centre weighted or evaluative metering modes would have resulted in the family being silhouetted against a correctly exposed sea and sky. Spot metering from the skin tone gave me the correct exposure for the family. Be careful with spot metering, it has pinpoint accuracy. If I had inadvertently metered from the woman's sunglasses rather than her face, I would have overexposed the entire frame. (Exposure will be explained later.)

150mm f4 1000th sec ISO 100

other stuff you need to know about cameras

Now that we have established the different types of cameras and lenses, understanding some of the other functions on your camera will help you to refine your working technique. Bear in mind that the terminology varies between different makes and models, but the functions are fundamentally the same. Check out your manual for your camera's specific wording.

metering modes

Cameras come with an in-built light meter to measure the light levels within your frame. You will learn more about how to read your light meter and adjust the settings in The Big Three, a little later in this book. Your camera will generally give you three different metering options: spot, centre weighted and evaluative. Here's what they do:

Spot measures a single point within your frame. This is a useful mode on occasions; it comes into its own when shooting in extreme lighting conditions, for example backlighting, or when you have a very bright or very dark subject that you want to ensure stays within the correct exposure.

Centre weighted measures the centre of the frame, which is fine if your subject happens to be in the centre of your frame.

CENTRE WEIGHTED METERING
The camera meters from the entire frame but assigns the greatest importance to the central portion of the frame.
40mm f5.6 200th sec ISO 200

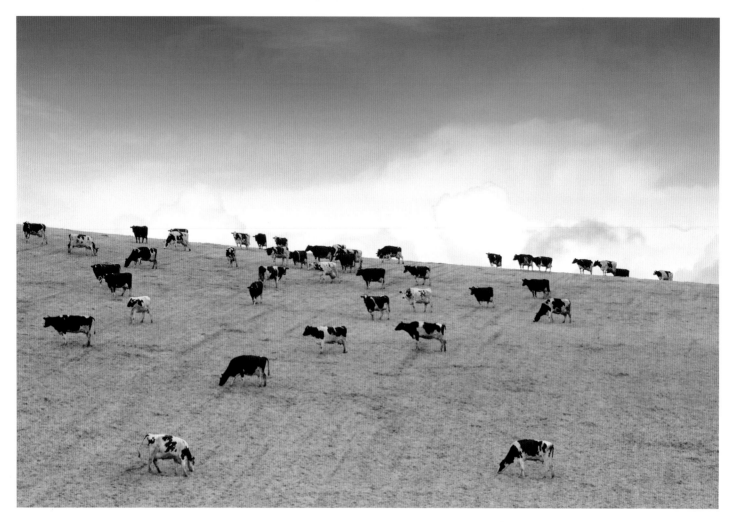

EVALUATIVE METERING

Recommended for most situations, the camera meters from the entire frame taking into consideration highlights and shadows. This scene is clearly made up half of sky and half of land; the evaluative metering has done a good job to calculate the correct exposure, holding detail in the clouds. The black in the fresian cows, however, is slightly underexposed. With extreme tonal range it is impossible to expose every part of the scene perfectly. Shooting this in RAW (see File Types for explanation) meant I was able to record as much detail as possible.

70mm f10 200th sec ISO 200

Evaluative (sometimes referred to as matrix) this incredibly clever mode will take a reading from the whole scene including the darker and brighter areas. This is the most commonly used and the most useful option.

Remember that your camera's meter may interpret the scene completely differently to how you would like it to be exposed. To find out how your camera behaves, practise taking a backlit scene using the different metering modes – you'll be surprised at the varying results that you'll obtain.

focus modes

Focus has three general settings: M, S and C.

M is manual focus. *You* control the focus by rotating the barrel of the lens, and using your eye to select which part of the image you want in focus. Simple. This can be a great way of working, as sometimes your camera's auto focus will struggle. However auto focus can *also* be a great way to work, once you have got your head around the different modes and the way the camera selects the focus point within the frame.

Auto focus has two general modes: S and C. The S stands for single servo auto focus, where the camera will focus when the shutter is pressed half way, and will lock focus while the shutter button is held. C stands for continuous servo auto focus, where the camera focuses continually while the button is depressed half way. When the subject moves, the focus will track the moving subject.

I use all three focus modes, depending on the subject I am shooting, for example:
M is useful when the auto really can't cope, for example focusing on a bride's face through her veil
S for general shooting
C for when a subject is moving toward or away from you, within the frame.

Area mode selector and single point mode

Within auto focus you need to understand about your area mode selector. You will have a variety of baffling options, I suggest you master the 'single point mode' option:

Looking through your viewfinder you will find a highlighted/flashing symbol that indicates the point of focus; by default this will be bang in the centre of your viewfinder, not necessarily the correct position. You should move this to your desired point of focus. You will need to discover how to move this point around by looking in your camera's manual. It's worthwhile doing this as you will be able to pinpoint and more importantly control exactly where and what you want your camera to focus on within the frame.

top tips

✱ By pressing the shutter halfway, you will engage the camera's metering and focusing

✱ If your auto focus is struggling to find focus, set to manual focus or use your focus area mode selector to tell the camera which part of the scene to focus on

✱ Before shooting, always check your setting, image quality, metering mode, and focus mode

✱ If you wear glasses you may need to adjust the 'diopter' on your viewfinder to sharpen up its focus for your eyes (check your camera manual)

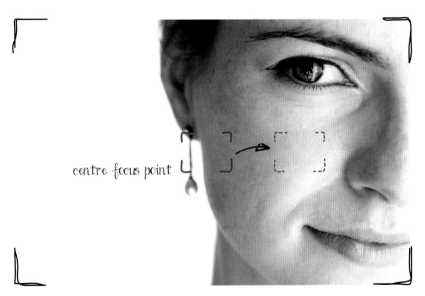

centre focus point

MOVE YOUR FOCUS
It's a common mistake for composition to be led by the flashing centred focus point. I wanted this radical shot to be off-centre, to ensure that her eye was pin sharp I had to move the focus point from the default centre frame setting on to her face.
80mm f2.8 125th sec ISO 200

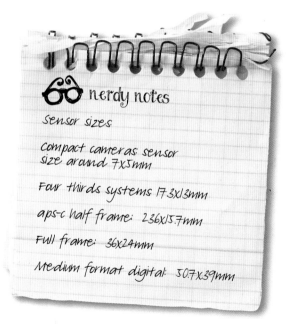

👓 nerdy notes

sensor sizes

Compact cameras sensor size around 7x5mm

Four thirds systems 17.3x13mm

aps-c half frame: 23.6x15.7mm

Full frame: 36x24mm

Medium format digital: 50.7x39mm

 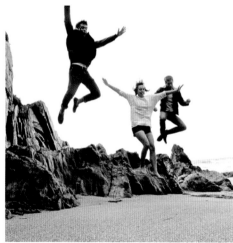 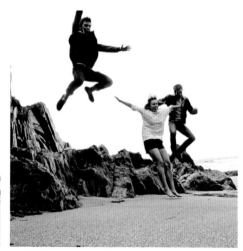

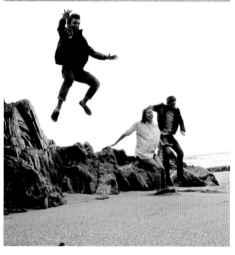

CONTINUOUS DRIVE
Put your camera onto continuous drive mode to capture a sequence of action. You may find there will be a delay while your camera stores the files to the memory card.
24mm f8 500th sec ISO 400

drive modes

Your camera will offer a variety of ways of capturing one or more frames:

Single frame will shoot one frame at a time, with each press of the shutter.

Continuous will shoot one frame rapidly after another, until the shutter is released. This is limited by the camera's buffer and how many frames per second your camera is capable of shooting.

Self timer Generally this will give you a three- or a ten-second delay before the shutter is fired.

Mirror lock This is worth understanding, particularly when you need a longer exposure, as even the mechanical action of the mirror flicking up could cause camera shake and result in a blurred image.

file types

The main two file types that you will encounter are **JPEG** and **RAW**. Most common and universally recognized is JPEG. Set on JPEG, the camera will compress the file to a more manageable size. It will also apply some basic processing to improve colour, contrast and sharpness.

When shooting in **JPEG**, most cameras will give you options on image size:

small, medium and large. This is normally measured in pixels. You will also need to set the image quality, which refers to the amount of compression applied to a file, choosing basic, normal or fine. Ideally I would always shoot on the largest possible image size (large) and on the highest possible image quality (fine). Bear in mind you can resize images in post-production. Basically you need large files for making printed photographs and small files for sharing, where they will only be viewed on

♥ Ideally I would always shoot on the largest possible image size

screen. Check to see what image quality and image size your camera is set on. By default, cameras will not always be on their highest quality setting.

RAW files are uncompressed, therefore much larger files. These will take up a lot of space on your memory card and computer, but will hold much more information in the colour and tonal range within the image. Each make of camera has its own kind of RAW file, for example Nikon has NEF, Canon CR2. When shooting on RAW the camera applies minimal processing to the image, so

this needs to be done in post-production. As a professional I always shoot on RAW, it gives me much more quality and control over the final image.

the camera sensor

The sensor is the most important part of your camera; it's the bit that makes your image, in effect the digital version of film, with all the variety of different sizes and formats. Commonly in a compact you will find a very small sensor and in a DSLR you will find a half or full frame sensor.

As a general rule, the size of the sensor will affect the quality of your image and will also affect the focal length of your lens (see Lenses Explained). Sensors are susceptible to dust, which can damage the sensor and will result in marks on your images. Many cameras have an auto sensor cleaning function, which will shake the sensor to remove the dust. However there are times when a mark will remain, and the sensor will need to be cleaned physically, using a wet/dry method or compressed air. There are kits available to purchase but be very careful, as if this is not carried out correctly you could permanently damage your camera's sensor. If in doubt, take it to your camera dealer or specialist for help.

what gear to buy

There are so many makes and models in the marketplace, it can be very confusing, and no sooner than you have done your research on one type it's superseded by the next all-singing version. Bear in mind when we talk about the photographer's kit bag that I think we should look at all the tools of the trade: not just the camera and lens, but also the computer, printer and the software you use with them.

Debating Nikon versus Canon and Mac versus PC can be left to the many consumer magazines and forums out there. I am a Nikon and Mac girl, but you can make images just as well using anything else, it's just a case of finding what works for you.

'the db5 is a car madam'

It's a common misconception, that you need a lot of very expensive equipment to be a good photographer. Not true! Of course, good gear does make a difference, but a very well known photographer once said to me 'if you can't take a successful image with a standard 50mm lens, give up'. Harsh, but the point here is, and to coin a phrase, 'you can have all the gear but no idea'.

For a lot of people their interest in photography is about the shiny and beautifully engineered cameras and gadgets. For me personally, and I don't think I am alone, I find that bit the least interesting. It has to be about the images you create at the point of pressing the shutter, not the gear in the first instance nor the software tools in post-production. The point at which the shutter is fired, and an understanding of what you are ultimately trying to achieve at

that point, is what really good photography is all about.

So where to start, and what to buy? Bear in mind that if you are buying a system camera compact or DSLR, you will need to consider both the camera body, and the lenses to go on it.

cameras

You're not likely to want to use a large format 10x8in plate camera, but you will probably own and use at the very least a phone camera, a compact and possibly a big new shiny DSLR. Or perhaps you are on the threshold of making the difficult choice of what to buy?

I use different cameras on different occasions: always my smart phone, a small good-quality compact for when I am on

holiday and I don't want to carry a bulky camera and a DSLR for work and specific photography projects.

If you are serious about your photography then you need to commit to getting off auto and learning about the basic principles of photography, which we cover in The Big Three later. As a novice, I think it's easier to learn on a bigger camera with all the manual functions easily accessible and the direct view through the viewfinder. A bit like when you first start to learn windsurfing – they give you a great big board, and you don't progress to a nippy little board until you have the hang of it. If you're in the market for a new camera, I would recommend that the best camera to learn on is a DSLR. If you already have a bridge or a compact then that's fine, but you will have to accept that you probably won't have easy instant access

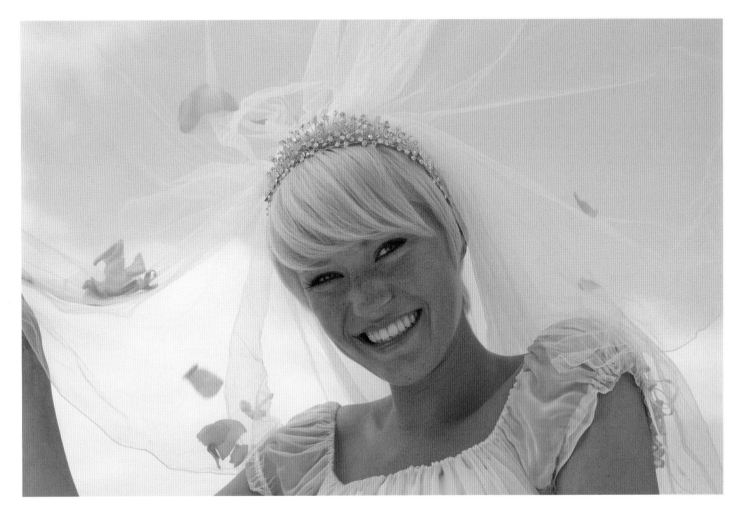

to the controls for your manual exposure. You may have to work just a little bit harder to find out where the settings are, or shoot on semi auto modes. Once you know what you're looking for it all becomes much easier and you will get to know your way around your camera.

What is your budget? Some of the professional standard gear will require a small mortgage. The more expensive, the more features – tougher bodies, weather sealing, higher frames per second rates, and bigger buffers to process files super quick – however when you're starting out many

of the 'pro-sumer' cameras (those aimed at the pro/amateur market) can handle most demands, just not with quite so much speed or fine tuning perhaps.

You also need to consider the 'megapixel debate'. A megapixel simply means one million pixels, and a pixel is a single point (or dot) in a photographic image. If your camera is 12 megapixels, it means that any pictures it takes on its highest quality setting will consist of 12 million of these pixels. There is an awful lot of nerdy tech-y talk bandied about, I can't recall the number of times I am asked 'how many megapixels is that then?'

YOUNG BRIDE

To achieve this shot I lay on the ground using the sky as a backdrop, exposing for the bride's face, and using a reflector to bounce the light back into the bride's face and eyes.
40mm f5.6 250th sec ISO 100

top tip

* Are you left-eyed or right-eyed? Depending on your answer, the layout can be awkward on some models. Make sure you pick up and hold the camera before you buy

by someone gesturing to the camera around my neck. My reply is usually: 'enough'. The camera is a mere tool; some of my favourite and best shots ever were shot on my now obsolete Nikon d1 as JPEGs and, yes, they may not withstand huge enlargement and may have less detail than I would prefer, but the shots are still good. Really these issues

> *There is not much point having a fantastic camera if you stick an inferior quality lens in front of it*

are now much less of a problem. Technology moves on and image quality becomes easier to achieve by shooting RAW and using genius photo software, and to quote 'it's not about size, it's how you use it'.

All the leading brands make solid reliable cameras. All will vary, with slightly different colour rendition, different noise patterns and different lens options. Do your research, read the reviews, and find a camera that you feel comfortable with at a price point you can afford. If you're cash-strapped then a lot can be bought second-hand, and as you develop your skills you can upgrade. There are some fantastic second-hand cameras, and don't forget you can pick up some exceptional film cameras and lenses for next to nothing, many people still prefer to shoot on film. Don't get too hung up on it, get on with taking pictures, that is what it is about.

lenses

A zoom is so versatile and in my book absolutely indispensable, I keep a 24–70mm f2.8 on my camera at all times: it's my default workhorse lens. The temptation is to buy one lens which covers a huge range of focal lengths, from very wide to very telephoto. Beware, although versatile, there will be a big compromise in quality unless you are paying a very large amount of money.

There is not much point having a fantastic camera if you then stick an inferior quality lens in front of it. Choose a quality lens with solid construction and good quality optics over range, this will always outperform a lightweight lens with ambitious specifications. If money is tight, start with a prime 50mm, the beauty of a system camera is that you can expand on your kit. Thinking about it, some of my lenses are nearly 30 years old and still in use.

the bag and other bits

There is no such thing as the perfect bag – if you're an outdoor photographer you may want a waterproof back-pack – I have a couple of different bags that I use, depending on the job. It's important to have something strong, with a zip and padded compartments to protect the gear.

Tripod

This is an essential tool, although I use mine less and less these days, as longer exposures are not as necessary with the ability to maintain quality at a higher ISO (see The Big Three). However there are always occasions where I need it and it's always in the boot of my car. There are many shots that would be simply impossible without it, and a tripod will help you take a more measured approach to shooting. Also, I sometimes use a monopod in crowded and tight situations, and it can be useful for raising the camera high above a crowd for a wide shot with the self timer set to make the exposure.

Reflectors

These are invaluable as they allow you to bounce and diffuse light. They tend to come in a pop up form in white, gold and silver, all are useful. Use with care lest you blind your subject. The white is softest, and the gold very warm. I also use a diffuser to soften harsh sunlight. You will need to prop this up using a stand or better, have someone to help hold the reflector in position.

Accessories

Memory cards come in different sizes and speeds. Memory is now much cheaper, so it's not an issue to have a number of spare cards. Better to have a few smaller cards than one large one, as if you have a problem with the card you won't lose all your images in one go. The more expensive cards will record the images more quickly. Always make sure that the card you are buying is compatible with your camera.

Colour filtration can now be easily applied in post-production but some filters are still useful to have in your kit bag and can allow you extra creativity in your work. A polarizer will cut out reflected light; it works really well on a bright sunny day to give deep saturated colour and dramatic clouds. An 'ND' filter means 'neutral density', in effect this works by cutting down the amount of light entering the lens, allowing for a longer exposure. This is a highly popular technique with landscape photographers when shooting water.

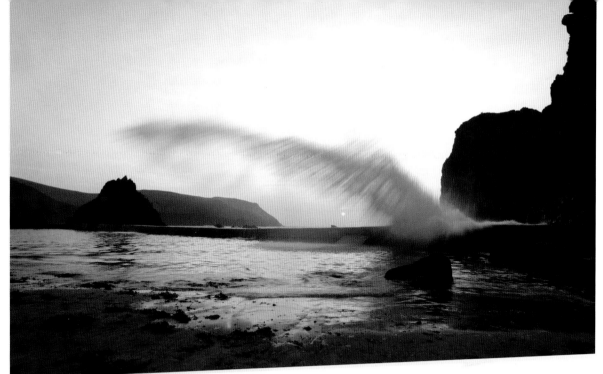

HOPE COVE

Without a tripod this shot would not have been possible. In order to capture the movement of the wave, a slow shutter speed was required, putting the camera on the tripod allowed for everything else in the scene to remain sharp. 14mm f14 1/6th sec ISO 100

my recommendations for a really good do-it-all kit would be:

- A DSLR camera body, one with all the manual functions easily accessible. A good quality *fast* zoom lens (see Lenses Explained), or better still two zooms that take you through the range: a wide to medium range telephoto, say a 28 to 70mm, and one to take you from 70 to 200mm.
- Plenty of memory as you should shoot at the highest possible resolution or better still RAW. This results in bigger files and will therefore take up more space.
- A tripod, for long exposures and landscape photography. This will give you the ability to use you camera at its full range of capabilities and in low light without too much compromise on the quality of your images.

- A simple pop-up disc reflector that can bounce light onto your subject and transform it.
- Last but by no means least, photo software for your computer to process your files correctly. If you are shooting a lot, then a fast computer with a few additional hard drives is probably a good idea, as photographs do chew up space and require a fast processor.
- On your wish list: a prime, standard 50mm, lens and a macro lens, for shooting the small and beautiful up close; and a detachable, dedicated flashgun to mount on the hot shoe of your camera, for a more sensitive approach to shooting with flash (better than the built in pop up flash units on some models).

the big three

Becoming an accomplished photographer requires distinct skill sets. You must learn how to drive your camera, to tune in and compose your image, and to control the post-production process so you can print and share. In order to 'drive your camera' you have to understand The Big Three, the fundamental functions that govern the exposure, so that's what we'll talk about next.

To master The Big Three you need to understand where on your camera the necessary modes/functions and buttons are to control them, and how to use and read your camera's light meter.

The Big Three are:

- **ISO**
- **Shutter speed**
- **Aperture**

By regulating and adjusting The Big Three on your camera, you control and make 'the correct exposure'.

Exposure is all about how much light you let into the camera: too much, and your photos will be washed out (overexposed), too little and they'll be too dark (underexposed). Exposure is measured by the camera's light meter (see Exposure and Metering) and controlled by adjusting The Big Three. A question I've heard more often than any other is 'what should my exposure be?' and my answer is always the same: 'your exposure should be correct!' It will of course vary, and the same exposure can be arrived at by using different combinations of The Big Three. It's a balance – and one that's well worth mastering.

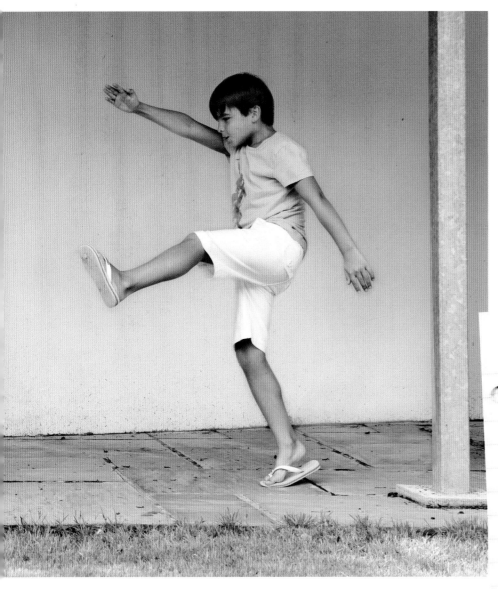

MARCHING BOY

This young boy was typically hyperactive, so I had him march up and down using the posts as a fixed point within in my frame rather than move the camera with him. There are many great shots of him in this sequence, this one is my favourite.

50mm f5.6 1000th sec ISO 400

♡ 'what should my exposure be?' My answer is always the same: 'your exposure should be correct!'

M	Manual
S	Shutter Priority
A	Aperture Priority
P	Programme mode
	Night
	Night landscape
	Sports
	Macro
	Landscape
	Portrait
AUTO	Auto

On any of the auto settings the camera is making all the decisions about exposure for you; easy and perfectly fine until you want some creative control. Using your camera on manual (M) or the semi auto settings (S or TV for shutter priority and A for aperture priority) (see Focus Modes) gives you the creative control to refine your exposure and be more creative with light. These are the only three main settings you should defer to, and these are always found on your mode dial. Depending on the make and model of your camera these letters also sit alongside programme mode (P), which is a more adjustable auto setting, and some familiar diagrams for auto, portrait, landscape, macro close-up, sport and night modes.

'M' for fully manual

On the manual setting you will be in complete control of The Big Three (ISO, shutter speed and aperture), and by using your meter you can arrive at the settings to control the correct amount of light onto your sensor to give you the correct exposure. Every single image you take will need to be individually assessed, by metering and tweaking, with adjustments made to the ISO, shutter or aperture to get the desired exposure and effect.

This is complicated to do smoothly, at first it can feel like 'patting your head and rubbing your tummy' and spinning a few plates as well. So I am not suggesting you go straight from auto to fully manual shooting. I am asking you to understand and familiarize yourself with how to do so, and from this 'throwing you in at the deep end' you will gradually grasp and gain creative control over your exposures and image making.

Semi-manual – 'A' and 'S'

You won't be using your meter, the camera will be automatically doing that for you, but you will be making the settings for your shutter speed or your aperture.

On the shutter priority setting 'S' or 'TV' you will be controlling just the shutter speed and your camera will automatically be adjusting the aperture.

On the aperture priority setting 'A' you will be controlling just the aperture and the camera will automatically be adjusting the shutter.

On the aperture and shutter priority settings, you can tweak the exposure of your image making it lighter or darker using your compensation button.

the exposure compensation button

A magical little short cut that will override your settings, so you can tweak them to allow less (-) or more (+) light in, to achieve the correct exposure. If you're shooting in semi auto modes this will be an essential tool to fine-tune your final exposure. Remember to re-set your exposure compensation button to zero, otherwise you might confuse yourself next time you make an exposure.

iso

The ISO setting controls how sensitive your sensor is to light. Strictly speaking ISO refers to the light sensitivity of film, for those busy girls who are old enough to remember film. As a couple of examples: ISO 50 would be 'slow' therefore useful for bright environments, with no 'grain' or 'noise', as opposed to ISO 1600, which would be 'fast', useful for low light environments, and producing grainy or noisy results.

The ISO setting on a digital camera works in much the same way as film speed, dictating how sensitive the image sensor is to light. Lower ISO, means lower sensitivity, more light is required to produce a correct exposure. Images shot at lower ISO that are correctly exposed will have less 'noise' than if shot on a high ISO. So in brighter situations it is best to set the ISO low.

Higher ISO, means higher sensitivity, less light is needed to produce a normal exposure. This also results in more grainy or noisy images with less recorded detail. In darker situations you will need to set your ISO high, and accept the loss in quality, although with newer generation digital cameras this is far less pronounced, and

is perhaps where camera technology has made the biggest advances. However even with these advances there is less latitude for error in your exposure at higher settings, so as with all these things, I like to use my brain to assess the ISO and keep it as low as possible for the particular shooting environment I am in.

If you find all this really confusing, I find it helpful to use 'the car heater analogy'. Here it is: when you get into your car in the morning and it's cold, you set the temperature dial to suit. In much the same way I assess how bright the environment is that I am shooting in and set the ISO accordingly. Bear in mind the light levels can fluctuate and change rapidly, for example at a wedding where you might go from inside a dark church to outside into a bright sunny day, so you would change your ISO from fast to slow. The same goes for the car heater, which you would turn down if conditions warmed up.

Setting my ISO is always one of the first exposure decisions I make, and I will change it if the light levels alter significantly. With practice this becomes second nature. You could of course have your ISO set on Auto, you can even set your ISO within a specified range, but I prefer to know what my camera is doing, as there could be occasions when it is selecting a higher than necessary ISO setting and losing quality unnecessarily.

shutter speed

Depending on the make and model, your camera may offer shutter speeds from a high velocity, such as 1/8000s, all the way down to 30 seconds, but most will have a good broad range for you to tackle most scenarios.

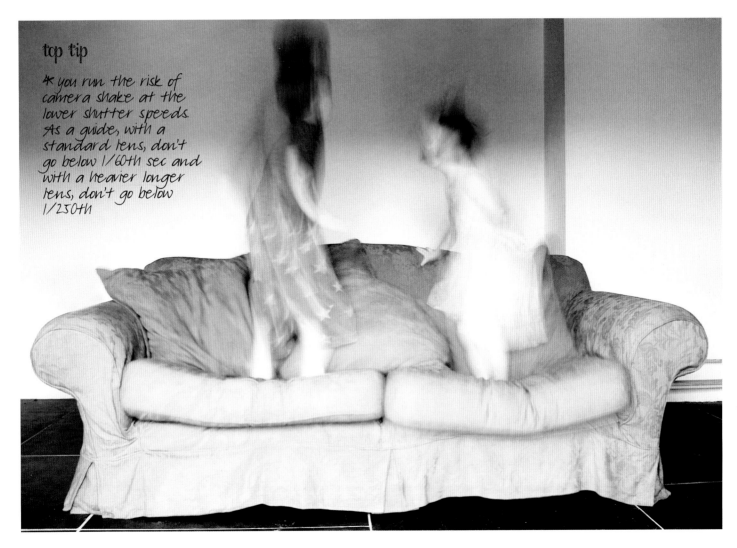

top tip

* you run the risk of camera shake at the lower shutter speeds. As a guide, with a standard lens, don't go below 1/60th sec and with a heavier longer lens, don't go below 1/250th

The shutter function controls how long the shutter is open for, allowing more or less light to pass via the lens through to the sensor. Fast shutter speeds allow less light to pass through, and are useful for 'freezing' fast movements. Slow shutter speeds allow more light to pass through, and can be used in darker conditions or to produce motion blur effects.

If you go below 1/60th of a second you will need to put your camera on a tripod, as you will physically not be able to hold the camera still enough to keep the picture sharp. With a telephoto lens you will also struggle to hold the camera steady so you will need to select a faster shutter speed.

You can use your shutter to affect the image creatively, for example, shooting a waterfall, by using a tripod and setting a slow shutter speed, you can record a much greater volume of water, making the fall look very impressive and moody, or at the other end of the scale you can use a fast shutter speed to freeze fast action, which is good

BOUNCING ON THE SOFA

Here, I used a tripod and a 1/5th of a second slow shutter speed to blur the children and keep the sofa and room sharp and in focus.
50mm f8 1/5th sec ISO 200

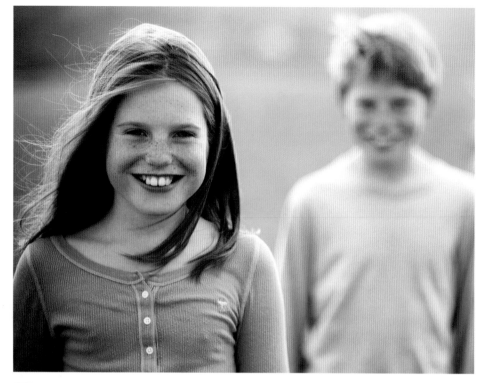

for sports photography. The subject you are shooting and the effect that you are hoping to achieve should dictate which setting you decide on.

aperture

This, the last of The Big Three functions, is measured in f-stops, and refers to how much light can pass through the lens to the sensor or film. Just like the iris of your eye responds to light and dark by increasing and decreasing in size, the 'leaves' inside your lens adjust the size of the aperture.

The larger the diameter of the aperture, the more light can pass through the lens and the lower the f-stop number.

The smaller the diameter of the aperture, the less light that can pass through the lens and the higher the f-stop number (see diagram for Specialist Lenses).

On your manual and semi auto settings you can adjust the aperture, in f-stops, to control the amount of light reaching the sensor to make the correct exposure. On auto the camera will set the aperture for you, but of course it won't necessarily be the exact one you want for the creative effect you are particularly looking for, therefore learn how to control it for yourself.

DEPTH OF FIELD

These images illustrate not only depth of field but also the point of focus. Using a prime 85mm lens with a very wide 1.8 aperture I was able to achieve a very shallow depth of field, the point of focus is on the girl's eyes and her brother behind is soft and out of focus. In the second frame I simply moved my point of focus to the boy.
85mm f1.8 2000th sec ISO 100

Aperture also controls how much of the image is in focus, this is called 'depth of field'. A large aperture produces a shallow depth of field with only a narrow area of focus; a small aperture produces a large depth of field with a wide area of focus. 'Depth of field' is a baffling term loosely meaning whether your focus is sharp throughout the image from foreground to background or whether focus falls away giving a soft and blurry effect.

A long lens, focused close to your subject with a wide aperture will maximize the effect of a shallow depth of field, at the other end of the spectrum a wide lens with the smallest aperture, used when you are stood well back from your subject, will offer the greatest depth of field.

There is a complex science involved in all this, and you will find some of the explanations of depth of field can be really confusing, but experiment with the different apertures on your different lenses and you will see for yourself the variety of effects that can be achieved.

WEDDING BOYS

To freeze fast-moving action you will need to select a fast shutter speed. This was a grab shot, I had a long lens on the camera in order to capture the boys quickly, I set the camera onto S shutter priority and selected 1/800th of a second to be sure to freeze the movement. The final exposure on this bright sunny day was f8 1/800th sec ISO 400.

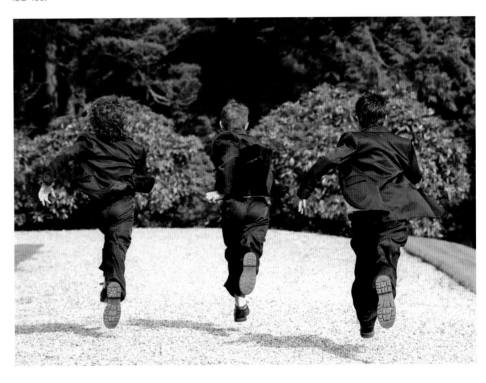

depth of field explained

The term 'depth of field' describes the distance in front of and behind your subject that is sharp and in focus. It is controlled by three main things the aperture, the focal length of your lens and the distance you are from your subject.

Simply speaking, a large aperture produces a shallow depth of field with only a narrow plane of focus. This can be used to good effect if you want to soften and blur the background and keep only your main subject as the point of focus. In contrast, the smaller the aperture the greater the plane of focus - important if you want to show more or all of the detail in the foreground and distance, typically useful for landscapes or bigger groups shots, where you want everyone and perhaps the setting behind to be in focus.

eureka!

exposure and metering

When I first started taking pictures I was lent an old and battered Nikon f1 with a prime 50mm lens (that makes me sound quite old – I'm still a girl at heart though). I loved that camera, it was so simple. The light meter was just a basic swinging needle, like a metronome, with a plus and minus indicating over and underexposure. You knew when you had it more or less right when the needle was in the middle. Watching the swing meter and adjusting the shutter and aperture settings, taught me a lot about exposure. Don't forget that in amongst all the flashing displays on your digital camera, the principles are just the same as an old film camera. Identifying where your meter, aperture and shutter are displayed in your viewfinder is the first step to getting off auto and taking control.

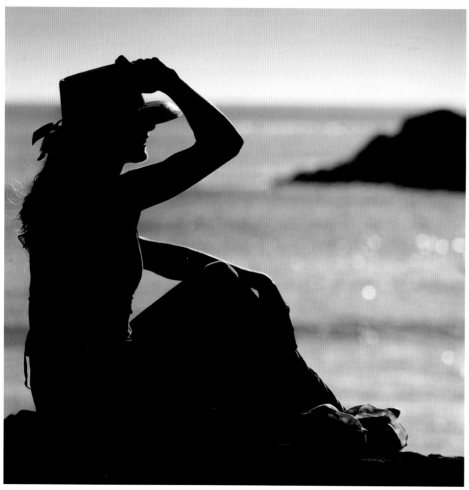

EXPOSURE

There is no one right way to expose for a scene – it's a creative choice. In this example, exposing for the background and silhouetting the lady produced a great image. Exposing for the foreground and letting the background overexpose produces a very different but equally strong shot. There are approximately four stops difference between the two frames, giving a completely different look and feel to the images, both of which have equal merit.
Silhouette: 150mm f4.5 4000th sec ISO 400
Girl on wall: 150mm f4.5 250th sec ISO 400

The art of metering is of course a little more involved, than getting the needle to the middle, but that is a very good starting point.

Certain scenes and lighting conditions are very difficult to meter correctly, backlit subjects for example are notoriously difficult; the camera metre will read the brightest part of the scene, often the sky, and therefore the main subject will be underexposed. In situations like that you have to meter from the part of the image that you would like to be correctly exposed. I tend to get up close and zoom in on what I would like to be exposed correctly, dial in my settings, frame and shoot. Not all situations are as tricky as this, it's easier to meter a soft low contrast scene.

It will take practise. Get into the habit of always looking at what your displays are telling you, firstly you will start to become familiar with the numbers and what they stand for and secondly you can check that your camera is not 'leading you up the garden path'. For example, you're on 'A' for aperture priority and you are shooting a group of people, you have selected an aperture of f8 as you want everyone to be in focus from the child on the knee to Grandad in the back row. The light is fading so your camera is automatically selecting an ever slower shutter speed until at 30th of a second and below your pictures are going to be blurred. Hopefully because you are taking notice of your settings, you can avert this,

ANOTHER BACKLIT SCENE
Here, I metered and exposed for the little girl not the overall scene, most of the detail in the water and background has been lost as it's brighter than the shaded side of the child. A shallow depth of field using a longer lens futher softens the background, putting the emphasis on the child.
200mm f5.6 1250th sec ISO 400

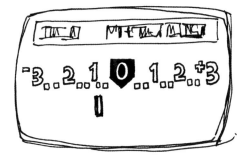

TTL LIGHT METER
Put your camera on its M – manual setting and discover your meter. Here it is showing the exposure as 1 stop underexposed. Identifying where your meter aperture and shutter are displayed in your viewfinder is the first step to getting off auto and taking control.

and increase your camera's sensitivity to light by upping your ISO or using a bit of flash, or getting a tripod and asking your group to stay nice and still (difficult if the child is moving and in low light).

It can be very frustrating trying to get the perfect exposure and re-create on the back of the camera what you are seeing with your eye. Cameras are only able to record a limited tonal range (the difference in exposure between the darkest and lightest points) within a scene, and this is nowhere near the range you perceive with your eye.

Take a bride and groom: a white dress and a black suit, you couldn't get more difficult; it's beyond the range of what the camera can record. If you expose the white dress correctly to show all the detail in the highlights, then the black suit will be underexposed and there will be no detail, and if you expose for the black suit the dress will be overexposed with no detail, so you have to make a judgement and expose somewhere in the middle. In this scenario the most important elements within the image are the couple's faces, therefore expose for the flesh tones.

Of course the way the image is processed in post-production will have another effect, and with this in mind, you should always aim to record as much information in the highlights and the shadows, that way you can make adjustments when you process your chosen files. This is when shooting RAW comes into its own, as your files will have much more information than if they were shot as JPEGs. You may not get instant gratification when reviewing your shots on the back of your camera as

they will generally appear a little more flat, but looking at your histogram (see What is a Histogram?) will reveal the exposure information, and you can make sure you have the detail in the image. Again don't get too hung up about this, if you are shooting RAW you do have a margin to correct your exposure in post-production and it's better to get on with creating the image than get constipated with the perfect exposure!

what is a histogram?

The histogram is a useful tool for measuring exposure, and you will encounter your histogram on the back of your camera and in most post-production software. It displays the exposure information of your image file as a graph, showing how much information is captured in the shadows, mid tones and

highlights. Looking at the graph and reading from left to right you will find the shadow information on the left-hand side and highlights on the right.

Usually, we assess our images by simply looking at them on the back of our camera, however be aware you won't be able to accurately judge your exposure in this way, and you may be disappointed when you later download the image to find that it is under or overexposed. To read a histogram takes a bit of practice but can give you the reassurance that your exposure is correct. By tweaking and adjusting your exposure and looking at your histogram you can be sure that you are bringing in all the detail you want, in the highlights for example. Don't worry too much about this: it's a useful tool that's worth learning about as you gain more experience. In reality most people only use this for more measured shooting, for product and landscape photography.

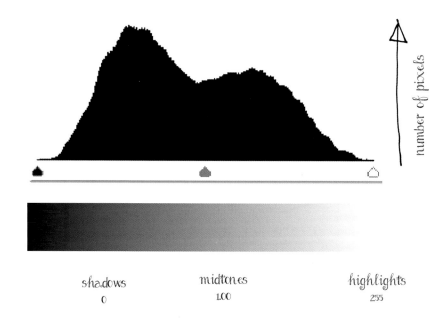

number of pixels

shadows
0

midtones
1.00

highlights
255

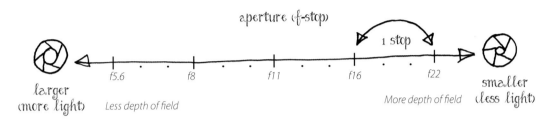

shutter speed (in seconds)

1 stop

slower
(more light) — 15th · 30th · 60th · 125th · 250th — faster
(less light)

Less motion stopping More motion stopping

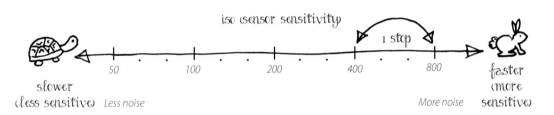

aperture (f-stop)

1 stop

larger
(more light) — f5.6 · f8 · f11 · f16 · f22 — smaller
(less light)

Less depth of field More depth of field

iso (sensor sensitivity)

1 stop

slower
(less sensitive) — 50 · 100 · 200 · 400 · 800 — faster
(more sensitive)

Less noise More noise

RECIPROCITY CHART

This chart shows the relationship between shutter speed, aperture and ISO. Doubling your shutter speed reduces the amount of light by the same amount as closing down your aperture one f-stop, or halving your ISO. This is often simply referred to as '1 stop'. When calculating your exposure this is useful to remember as changing one of your settings will mean that you have to balance the exposure with another. For example: your light meter tells you that the correct exposure is f8, 1/60th at 100 ISO, but you want to shoot with a shallow depth of field at f2.8. Your aperture is now letting far more light through the lens, so you must balance this with your shutter speed. F16 – f2.8 is a change of 3 stops, so we must increase our shutter speed by 3 stops also. This would mean changing from 1/60th to 1/500th.

nerdy notes

Histograms are a guide. There are also other displays available on your camera that can be helpful, for example overexposed highlights can be viewed as a flashing area on your image review. Learn more from your camera's manual.

top tips

✳ Remember it's only on fully manual setting that you will be metering and fixing your settings. When you shoot on the auto and semi auto settings the camera will be making the final exposure settings for you

✳ Practise adjusting your aperture and shutter settings and reading your meter without removing the camera from your eye – it will soon become second nature. Take note of how the settings are divided into a one third of a stop increments

✳ As a rule of thumb, fix your settings to avoid losing detail in the highlights

lighting

Light is the main and most important ingredient in photography. The 'quality' of the lighting and how you control it is really what makes or breaks an image, so it is generally one of the first things to consider when composing your image.

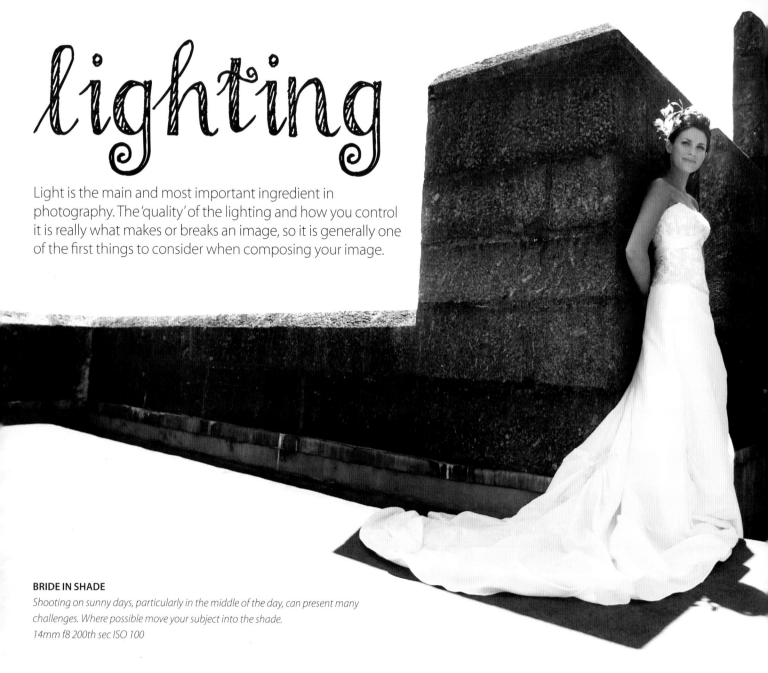

BRIDE IN SHADE
Shooting on sunny days, particularly in the middle of the day, can present many challenges. Where possible move your subject into the shade.
14mm f8 200th sec ISO 100

Nature provides us with the best and most variable lighting, often referred to as 'available' light, which includes everything from bright sunlight to moonlight. 'Artificial light' means everything else. The most commonly used artificial light in photography is of course flash, either built in to your camera or, even better, a detachable one for more controlled flash lighting. There are many other types of artificial lighting apart from flash, including incandescent and LED amongst others.

Generally we shoot with available light. Certain lighting conditions are much harder to shoot than others. Backlighting, although difficult to expose correctly, can, if you get it right, produce a beautiful dreamy look. Sunny days are always difficult as you need

success. Soft, even, natural, north-facing light is best, particularly for portraiture and still life. Landscape photographers generally love dramatic lighting, such as stormy days with interesting skies, and light moving across the ground. Wedding photographers would always prefer a bright but overcast day, much easier to contend with than bright harsh sunlight. There is no best or worst, it's 'horses for courses' and will of course depend on what subject you are shooting and the look you are going for.

Learning how to read and 'work the light' is a skill you will develop. As you gain more

♥ I use flash only when I absolutely have to, and in the most subtle way possible

experience you will learn how to tackle and make the most of awkward lighting situations, and by manipulating exposure you will be able to create beautiful images.

In our everyday environment, we also encounter tungsten, fluorescent and halogen bulbs, or a combination of these, mixed with daylight. They all have different colour temperatures; tungsten, for example, records a warm yellow colour cast. Our naked eye is very good at compensating for this. The camera will also compensate, as by default your camera is set on 'auto white balance' and for most scenarios this is fine. Mixed lighting can be tricky to balance, it's better to turn lights off, eliminate the mixture, and try and work with only one type of light source where possible. Again don't worry too much, you really only need to be

to contend with deep dark shadows and bright highlights. Of course 'the golden hour', when the sun is low in the sky and scatters soft even warm light over surfaces, offers a complete contrast to the intensity of the midday sun, and is usually a recipe for

concerned about white balance where the colour has to be very accurate, for example for product photography. Bear in mind that if you are shooting RAW, then all white balance adjustments can be made afterwards in post-production.

using on camera flash

An additional dedicated flashgun is preferable to the built-in or pop-up flash on most cameras; these can be a bit overwhelming and too direct. As with the lenses, make sure that the flashgun you buy is compatible with your camera body. These flashguns are connected to the camera by being mounted on the camera's 'hot shoe'. It is common practice to bounce the flash onto a wall or ceiling, or through a diffuser, as this will soften and spread the light over your subject.

I use flash only when I absolutely have to, and in the most subtle way possible. Wherever possible I try to expose for the available/ambient light, preferring to increase my ISO, either use my fastest prime lenses, maybe a tripod and longer shutter speed, to achieve the best exposure in low light levels. I only use flash to boost and gently fill.

Obviously there will be circumstances where any one of these techniques won't be suitable, and there are of course occasions when there is simply too little or no ambient light to make an exposure. Then you must resort to using your flash as the main light

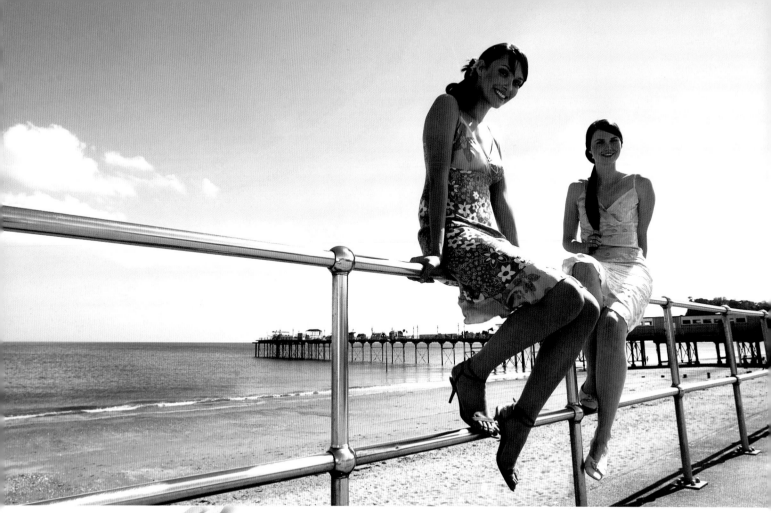

GIRLS ON RAILINGS

To achieve a balanced exposure on such a bright sunny day, fill in flash allowed me to lift the shadows on the girls faces and expose for the overall scene.
24mm f8 125th sec ISO 200

nerdy notes

'Fill' refers to additional light used to lift shadows, particularly with strong backlit subjects. Using either a reflector or flash, this is a very simple and very effective way to lighten up the darker areas in your image and to help balance your exposure.

source. However, direct flash is harsh, and I always hope there will be a pale ceiling or a wall, where you can angle your flash to bounce and illuminate the scene. If not, you can add a hood to spread and soften the light.

It's not only in low light situations that flash is indispensable, on very bright days and situations that are strongly backlit then 'fill-in flash' is essential. I try not to balance the light too much otherwise it all becomes a bit too flat and the subtleties are lost. I tend to use the compensation buttons on the flash for increasing or decreasing the amount of flash I want, to fine tune it. It's tricky to get right, but practising a few different techniques in different locations and lighting scenarios will help, and you should soon have the 'fill-in flash technique' mastered.

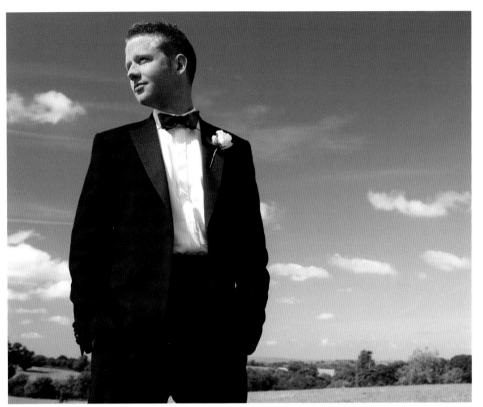

GROOM

I avoid shooting with direct sunlight on my subject, it can cast harsh shadows, and cause squinting. However, you can make it work for you; in this shot the man's face is turned to the sun which was low in the sky. I also used a polarizing filter to hold the blue in the sky.

36mm f6.3 1/320 sec ISO 400

top tips

* Always ask yourself before taking the picture: could moving yourself, your subject or the light source avoid potential problems, such as harsh shadows, to improve the image and exposure?

* In bright midday sun find an area of shade, it will be easier to expose and the results will be much better

YOUNG AND OLD

This was shot in the middle of a very sunny day, as can be seen from the bleached out overexposed background. This charming pair were nicely shaded in the diffused light of a big white parasol. I would have liked more detail in the scene behind, but I was more concerned with capturing the moment so only concerned myself with correctly exposing them.

34mm f6.3 500th sec ISO 200

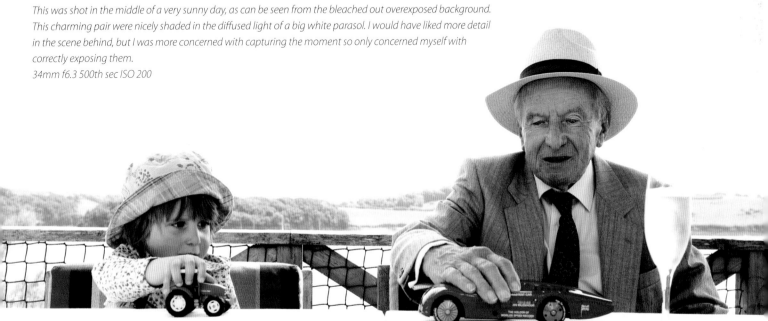

2: taking pictures

Do you have an eye? To be a really good photographer, you must have a natural disposition for composition. If you feel you are lacking in this area, take heart, it is definitely a skill that can be developed and worked on. I believe most of us girls do have an 'eye', but maybe we don't recognize it, or haven't tuned in to it yet.

So far we have talked about how to drive your camera, and now hopefully you have a better understanding of how to control your exposure creatively. As you become more fluent at using your camera, you will be able to concentrate and 'tune in' to your composition, unhindered.

Throughout this section we will be looking at composition in relation to it's specific subject. Taking each subject in turn, from people to still life, we're about to discover that different skill sets are required for different areas of specialization. Having said that, I think most genres can be attempted if you apply the basic principles of good working practice. Drive your camera and use your gear to best effect for the given subject, tune into your composition, use the light creatively, and process the resulting image for the best quality outcome.

GIG ROWERS

For a clean and graphic composition, I wanted perfect symmetry of the girls' arms. The hand in the foreground leads the eye in. It was a very bright day and the highly reflective interior of the boat is overexposed and detail is sadly lost – not ideal but the strength of the composition wins.
40mm f8 500th sec ISO 100

I approach every subject I shoot in the same way, whether it's a person's face or a panoramic landscape. First and foremost it's about the quality of the light on the subject. Within the frame, you must consider not just the main subject, but also all the other elements and how they relate to one another. There are as many ways of finding the perfect composition for an image, as there are photographers in the world.

When I first started taking pictures I knew nothing of the 'rules' of composition (see Composition Rules, explained later on), and I just arranged the image in my viewfinder as it pleased me. I still do. In much the same way as we shift our furniture around a room until it looks and, more importantly, feels right, so it is that sometimes, no matter how much we tweak, we can't make it fit the way we want. Perhaps the door or the wall is not in the right configuration, so a compromise has to be found; it's extremely rare to find the perfect composition.

The most basic rule to apply when 'framing' a shot, is to look beyond your main subject and scan the edges of your frame. You must consider every element within the frame and how each one relates to another.

The wonderful thing about photography is that it offers endless opportunities – there is always something to shoot, and you will never stop learning. At every shoot I discover and learn something new: a new trick or prop to provoke a response in an unwilling child; a new piece of equipment that perhaps alters my perspective; and from time to time I slip into a new style and my work evolves. For much of last year I wanted to shoot everything square – probably a direct development from using Instagram on my smart phone. If I am feeling lacklustre and lost for creativity then I turn to *Vogue* magazine and my collection of beautiful photographic books to be re-inspired by the masters.

As you gain shooting experience and tune in to your way of seeing, you will begin to formulate your own 'trademark' style.

how to tune in
and 'ways of seeing'

It is not enough to stand in front of your subject, bring your camera to your face and press the shutter, but generally speaking this is how I see most people taking a photograph. You must fully engage and really look at all the elements that you intend to frame before you shoot. Look from every angle and use your available gear to best effect. There are of course many things that will affect your overall composition – the light and how you choose to expose and process the image will greatly affect the final result – but the structure of your shot and the placement of the elements within your viewfinder will be the framework on which all the other ingredients of the image will be supported.

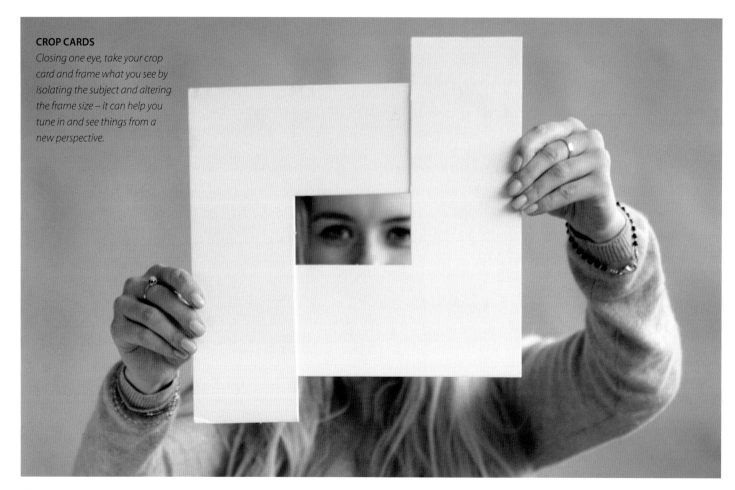

CROP CARDS

Closing one eye, take your crop card and frame what you see by isolating the subject and altering the frame size – it can help you tune in and see things from a new perspective.

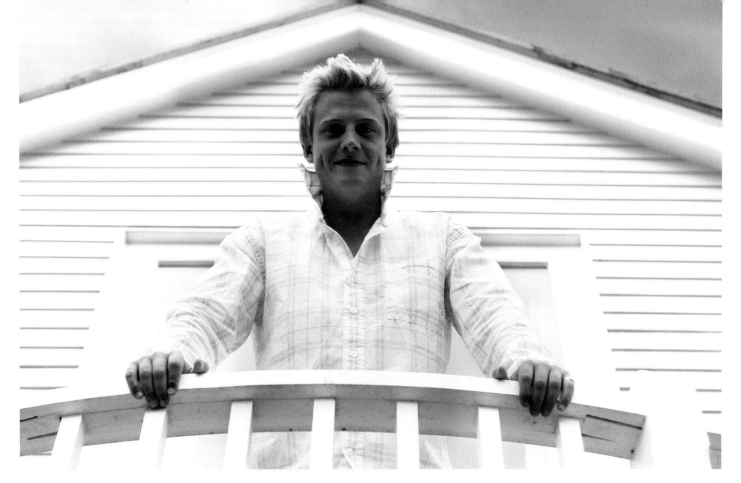

Whether you have been gifted with a natural disposition for composition or not, becoming good at it is something that you can learn and develop. Going right back to basics is a good starting point and I always open any workshop with a set of simple crop cards. It can feel like a pointless exercise at first but persevere. Take time out and look closely at the world around you, framing what you see, using this simplest of tools. You will find that without being distracted or hindered by the actual mechanics of the gear and using just your eyes, it really will help to focus your mind purely on composition. That in turn will put you in the right frame of mind to approach your photography from a more creative perspective.

It's probably best to choose a bright environment, preferably bathed with natural light, as the fluctuations and changing light play a huge role in your overall composition. Use the cards to discover and frame some compositions. Pay attention to the shape of your aperture: is the crop, square, panoramic, portrait or landscape? Look at light playing on surfaces, the highlights and the shadows, colour, tone, texture and shapes. Try to keep the composition clean and simple without too many elements to juggle. Pay attention to strong lines where they enter the frame and where they exit, reading left to right.

COMPOSITION DETAILS

I took ages lining the model up on the balcony to ensure that his head was centred and framed by the apex of the roof, also that his shoulders and hands lined up with the doorframe behind him. His upturned collar reflects the triangular shapes throughout the image. All the little adjustments matter to the overall strength of the finished frame.
90mm f5.6 500th sec ISO 200

top tips

✴ Always scan the outer edge of your frame and make sure that nothing unwanted is creeping in to your composition

✴ Less is more

composition rules
(and breaking them)

Over the years artists and photographers have developed many 'rules' for creating pleasing composition. The most basic of these is the 'rule of thirds': divide an image into thirds horizontally and diagonally; points of interest within the image should then be framed along these lines, and particularly at the intersection of these lines. Landscape photography can be a good example of how this rule is used, with horizons generally being framed along the top third of the image. Alternatively if you are taking a landscape photograph and wish to create emphasis on the sky, the horizon could be framed along the bottom third of the image. Another rule that is useful for composition is the 'diagonal rule', which states that important elements in an image should be set out along a diagonal line cutting across the image.

diagonal line

MAN AND BABY
This image is as shot, the cropping was perceived at the point of shooting, better than cropping in post-production for two reasons: the quality will not be adversely affected when enlarging the image, and, to get the composition right in camera involves 'tuning in' and fully engaging with the subject. Post-production techniques can create lazy working practice, and to give your work the edge always aim to get the shot in camera. Also note the strong diagonal in this composition that holds it all together.
50mm f5.6 80th sec ISO 400

COUPLE ON YACHT

This shot was perceived as a square format image. I composed the frame as far as I could 'in camera' getting the top, bottom and right hand edges as I wanted, then took the shot knowing that I would crop the left-hand side in post-production. 105mm f8 500th sec ISO 400

The most important rule to remember is that rules are made to be broken. Better to develop your instinctive natural eye for composition, than follow a set of bland rules. Have the confidence to commit to the frame in the way you see your world. You may not please all the people all the time and you run the risk of being criticized because your image does not fall into the regimented 'correct' rules, but if it is working for you and satisfies your creative perspective then that's all that matters. Your style and skill at composition will evolve and mature over time.

I like to crop tight into people's faces, chopping through the top of the head. This is not exactly a groundbreaking new style, look at any magazine and you will find many examples, but often a private portrait client will be really perturbed by this radical cropping, because it doesn't fit with the perceived correct format of a full head and shoulder shot. It's my style and I will always defend the creative choices I make.

people

This is a huge subject, covering everything from portraiture, fashion and family photography, and even editorial reportage style on an urban street. To get great images, the busy girl will need confident people skills; being a good communicator is as important a skill to own as having a good eye and technical competence.

FAMILY ON THE BEACH

This rather loose arrangement of a group has a lovely dreamy quality. Each figure or grouping works independently and this helps the overall composition. The de-saturated colour brought everything into a similar softer tonal range and lifted the rather drab lighting conditions.

45mm f8 200th sec ISO 200

Many people hate having their picture taken, so it can be a challenge to coerce a reluctant subject into position for a strong well-structured shot. Shooting people is a 50/50 shared process; you give your subjects great direction and put them in the best possible light, but it is up to them to work

with you as well. Charm and humour go a long way when you are working with people who are intimidated by the camera, it's very important to give both clear direction and constant reassurance.

Perhaps the biggest challenge when photographing people is posing and

By nature, many of us are vain and vulnerable about our looks. Taking this into account, perhaps more than any other subject, portraiture sets the highest bar. Candid shots, when people are unaware they are being photographed, are always a favourite. You will need to develop a photographer's sixth sense – always be on your guard and ready to shoot – to anticipate a spontaneous laugh, a kiss, an emotional tear. Although candid grab shots are great, they should be considered as the icing on the cake, and to achieve a decent quality and quantity of shots, stage management will need to be employed. Stage management should never result in staid or awkward poses, it should be done in such a way that the people involved in the shot don't feel like they are being 'posed'. Bear in mind that however busy you are, pre-planning the shot will always deliver better results. The setting for your subject should be considered as much of a player in the final image as the main subject itself.

What we find most engaging when we look at pictures of people, aside from being a good record and a flattering likeness, are 'pictures with personality' – either the personality of the person or the response to a moment, a twinkle in the eye, a giggle, a mannerism. All these things are import to capture if you can.

There will always be different requirements to meet, different locations and shooting styles. In the following section, I will give some basic tips and hints to address many common issues you may come across when working with people, either singly or in groups, large and small.

grouping them to look natural. It takes a lot of practise to build a repertoire of arrangements. Bear in mind that what works well with one grouping may not necessarily work with another; people's personalities, shapes and sizes will all factor in. Different approaches will be required for different

age groups. Shooting only one person is relatively straightforward, whilst groups are much more challenging to control and arrange. Throughout this section we will be looking more closely, at specific solutions to the problems you may encounter when photographing people.

babies

I love babies, and who doesn't? Obviously as a professional portrait photographer, I meet my fair share. They do however, as with all little people, present a problem in that they are highly unlikely to do what you want, when you want. The age of the baby will probably determine your approach to shooting.

Naked babies are the best, but do preserve their dignity. I always have plenty of soft white fabric and towels, as widdling and worse is to be expected. Reassure embarrassed parents that it's okay if this happens. If it's not okay, then leave the nappy on.

MAN AND BABY

Try to reduce the number of distractions in the image. Clothing can be distracting, so ask the parent to wear simple plain clothes so the main focus is on the little bundle. If they are holding the baby then they are as important in the shot as the baby itself.
90mm f5 125th sec ISO 200

top tip

* Parents will often stand to one side and sing and clap in an attempt to bring out a smile, and whilst this is great, it can cause the baby to turn and look up at them. Ask them to sit down as close to you as possible. Better still, if you can, ask them to stop so you can engage with the baby and have the baby looking directly through your lens, this will result in a much more powerful portrait

SITTING DUCK

At around six months old a baby is strong enough to sit confidently, holding up its head and engaging, but thankfully not yet strong enough to crawl off. So, given that the baby is not tired or hungry, you have, and pardon the pun, 'a sitting duck'. It's not difficult to find a good clear background (this could be the grass in your garden), some good even light and a naked baby. Add the ability to talk 'baby' and it's easy to achieve. 100mm f11 125th sec ISO 200

The shoot should be baby led. It's pointless trying to force a tired, grizzly baby to perform well. Stop if it's not coming together, rethink and recharge. A fed and rested baby will always be easier to work with.

If you have a macro lens use it to achieve lovely soft details of the hands, feet and face. It's tricky as little babies wriggle, so these shots are definitely best attempted when the baby is still or better, asleep.

As babies change so quickly there are optimum stages when it's best to shoot:

- **Newborn stage** I would classify babies up to ten weeks old as newborn, when they are just little unfurled bundles. As they can't really engage with you and the camera, it is often difficult to capture the 'ahh' factor. As they can't support themselves, newborns can also be difficult to pose independently. Incorporating the mother and/or father in the shoot, can help.
- **Pushing up babies** If the baby can hold its head up and push up on its arms, you can get great shots by getting down onto the floor.
- **Sitting up babies** The best kind of all! Not crawling, but captive and engaging.
- **Crawling babies** Can be difficult. The trick is to line up your shot and get them to crawl into it. If they can pull themselves up to a standing position, that can be a solution for keeping them stationary for a moment.

KISS ON THE FOREHEAD

Although the background is a little disjointed in this informal shot in the home, my first consideration was to pose the boy, sitting him cross-legged to create a cradle for his baby sister. The blanket supported and raised the baby. I shot from a low angle using a longer focal length further back from the subject, which was less intimidating and distracting. The shallow depth of field makes the background less distinct. Overall the shot works, mainly because the boy is old enough to manage a sleepy baby without struggling. I anticipated that he would only be able to give me about a minute for this shot, so I had to perceive it before I started to shoot. With boy and baby in position I simply asked him to kiss her forehead.
75mm f5 125th sec ISO 200

SURPRISED BABY

This baby was too little to sit up, so I laid him down and stood directly over him for a bird's eye view. Normally I would acclimatize the baby to me and the camera before I start, but I forgot on this occasion and startled the poor little thing. It was the first frame of the shoot and in my opinion the best.
35mm f5.6 80th sec ISO 800

LITTLE FEET

I always struggle to get this shot. A still and sleepy baby is best then you can position the feet how you want them and find the best angle. I used a macro to get up really close and fill the frame.
60mm f3 400th sec ISO 800

CRYING BABY

If the shoot has descended into tears and tantrums take a break. Keep shoots short when working with very young children, but if there are tears then capture them. She was giggling five minutes later and the parents love this shot – cheesy smiles are not always best!
60mm f2.8 125th sec ISO 800

tots and kids

Children are hugely rewarding to photograph, but tricky too as they have very limited attention spans. For shots where children are engaging with you and the camera, you will need to be quick and have quite a few tricks up your sleeve. Props will play an important role to keep them engaged, but the wrong prop can spoil the image; often I don't want anything else in the shot other than the child.

ON THE BEACH

This was shot on a lovely spring morning and although there was full sunshine it was low enough in the sky to not be too intense. I found a nice clean, smooth patch of sand high up on a dune near the grass and took the shot from a low vantage point. 50mm f6.3 160th sec ISO 100

CLASSIC FEEL

There is something 'old world' about this shot. It's the classic scene with soft, muted, desaturated colours. The shot is held together by the uncluttered foreground. The child's pose, the angle of her tilted head and the position of the child in relation to the rocky island are all important as had the rock and child joined, the composition would have been compromised.

50mm f5.6 500th sec ISO 200

Don't just point and shoot wherever the child or children happen to be, find a good spot or location to work in with them. Often, it is in the first few minutes of shooting, that you will get the most animated and natural expressions, so make sure you're all set up and ready for the action to unfold. The child will often tire of a particular set up before you have had a chance to complete your sequence of shots, so you will need to work quickly and use all your powers of persuasion to keep them engaged and working with you.

They will get bored pretty quickly. Be led by them and don't try to force them to carry on. If they are not co-operating, move on and try something different. Also don't try to achieve too much in one sitting, you do not want to be responsible for giving the child a life-long hatred of being photographed!

Lovely shots can be achieved when the child is at play and engaged. Again you can set up a few props in a nice well-lit environment and let the action unfold. A long lens is useful, as the child will be unaware of you shooting.

If you're not familiar with the child or don't have much experience of working with children, be guided by the parents as to what you can expect from their child. You may be a busy girl with time-pressures to contend with, but take a little time before shooting to get them acclimatized to their surroundings, and chat to the parents so they feel confident and secure around you. Let them see the camera, little children can often be scared of strangers and big menacing-looking equipment. Take it slowly with the more timid child.

When things don't go to plan and you simply can't get the child to co-operate, try employing a few child psychology techniques. For example, if a child won't join in a group, just ignore, and don't make a fuss or let the parents force the issue. Continue to shoot without the child. If they feel they are being left out, then more often than not they will come back in without any fuss. If that doesn't work, move on. You may not get everything you originally planned, so don't come back to that set up later expecting a different outcome.

Praise them when they are working well with you. Children love to please and a 'good boy!' or 'good girl!' go a long way to keep them motivated. Allowing them to be silly, pulling a face, a giggle and bit of naughtiness is fine up to a point, but it needs to be kept in check as this will often end in tears. Of course sometimes tears can make a great shot…

Motivate them, praise them and if all else fails, bribery will always work.

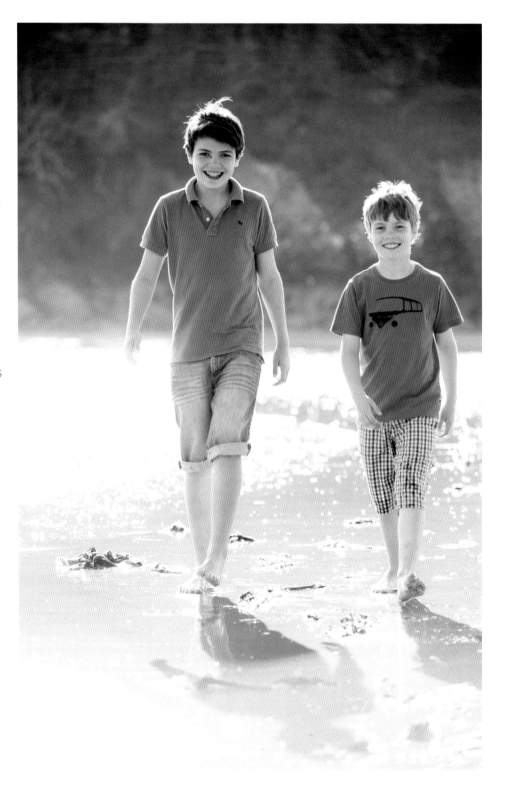

BROTHERS

Once I had grappled with the correct exposure for this difficult backlit setting, getting the shot was easy. Using a long lens, I simply asked the boys to walk towards me. They look more at ease than they would standing in a formal pose.
110mm f3.2 1000sec ISO 250

CHEEKY SMILE

Photographing kids, I spend most of my time on the floor. This is not only the best perspective to shoot from, it's also the best place to fully engage with young kids. This direct at-the-camera look and cheeky little grin was definitely a response to something I was saying to her. A simple game of 'peepo' can work wonders.
50mm f5 320th sec ISO 200

SISTERS

Three things make this shot work: the beautiful misty light and foliage, the structure of the wall, the formal positioning of the girls. It's not complicated – remove the girls and the shot still works.
50mm f8 320th sec ISO 800

top tip

✳ Just like the children, the parents will need to be controlled as they can be a help or a hindrance. Don't let the parents direct the shoot, you want the children to be engaging with you and the camera. Explain this to the parents before the shoot, but ask them to help you keep control as they will often know the triggers for a smile, or when to calm things down, and what is or isn't acceptable behaviour

teens

Teenagers will generally be fairly reluctant to sit for you. Often they are being included in a shot under duress, so some reassurance will be needed that their 'street cred' will not in any way be compromised. I quite like to capture the initial awkwardness and embarrassment. Shooting through this will often make them laugh and get them on your side, and hopefully working with you. Embrace the braces, acne and attitude.

However, it's not always all angst and attitude, often young and lovely teens will be totally confident and love the glamour and attention of a shoot. A fresh, confident young adult will offer the photographer the opportunity to push the boundaries and try something a little more stylized, using clothes, props and unusual locations. You will always get away with more with youth on your side!

ANGEL DRESS
It's always worth having a few extra clothes and props to experiment with – it can make or break a shoot. An electric fan is another very useful aid, helping to bring some movement to your image.
35mm f5.6 125th sec ISO 200

TENSION BUSTER
If your subjects are feeling a bit awkward, a gentle push fight can result in more light-hearted and natural interaction than a standard formal pose.
50mm f11 125th sec ISO 400

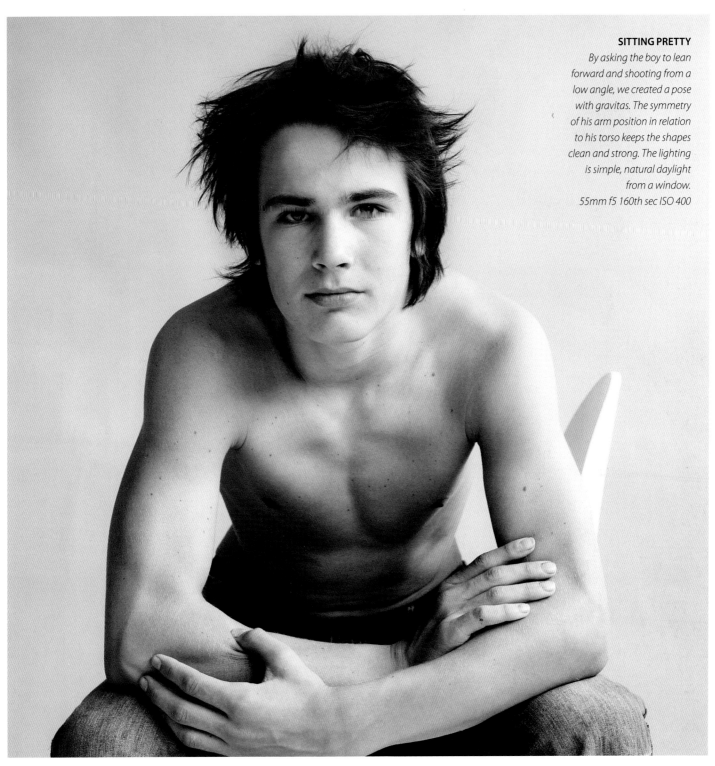

SITTING PRETTY
By asking the boy to lean forward and shooting from a low angle, we created a pose with gravitas. The symmetry of his arm position in relation to his torso keeps the shapes clean and strong. The lighting is simple, natural daylight from a window.
55mm f5 160th sec ISO 400

families and groups

It is perhaps 'the group shot' of our nearest and dearest that is the most commonly taken photograph across the board, and the one that most often disappoints. It is not an easy shot to achieve. It's important to capture the bond and relationship between the people in your group. Some friends and families are very reserved and will feel very uncomfortable about being 'touchy feely'. Other groups will throw themselves together, all arms and hugs – in fact this is often the default position, and results in everyone's shoulders being thrown up and clothes all out of place. You will need to rearrange and guide the people in the group into the best position, without it all becoming too posed and 'wooden'.

TARENTINO-ESQUE

The classic Reservoir Dogs shot – a bit of a cliché but this illustrates how much more relaxed everyone looks when you get them moving. You can only achieve this if there aren't too many people in the shot, take care to spread them out so you get everyone's face in the frame. A couple of attempts and you should nail it. I am, as usual, lying on the ground to get this shot – you have to suffer for your art.
30mm f8 500th sec ISO 200

MAKING THE MOST OF DIFFERENT LEVELS

Using the slope of a shaded slipway and the different height of the rocks I was able to stagger the people on different levels, ensuring that each person was clearly visible and looking good within the frame. 30mm f11 125th sec ISO 640

I have over the years developed a technique suitable for shooting any groups from four or five people up to three-hundred strong at a big wedding. Now, we all know how busy you are, but find a little time in your busy girl schedule, because a little planning goes a long way. You will want the group to look as natural, relaxed and informal as possible. The setting is your first consideration: have an idea of how many are in the group so you can choose a suitably sized space. Make sure it's evenly lit, and don't always be tempted to include the view, which is often suggested, as quite often the view will be obscured by the people in the frame. This is a picture about the people, not the view. More important considerations will be the light and some structure: steps, benches with arms, anything with different levels where you can stagger people, or space where you can spread out a little for larger groups.

I tend to start by placing a few people at a time into the frame and building on it, swapping people around until it looks right. People tend initially to sit or stand facing square on to the camera, passport style. This is not great, so encourage some of them to sit cross-legged with a bit of twist, leaning into each other. Different body positions are important to avoid the shot looking awkward and wooden. For a formal group, everyone's full face needs to be visible, and ideally looking and smiling at the camera.

Once you have everyone in position, a bit of banter and a countdown, '3, 2, 1', usually gets them smiling and 'loving the camera'. Always shoot plenty. I often place the camera on the tripod, it helps me to keep an eye on them. I can engage with them and be firing off shots at the same time.

For a less formal approach and if space and location allows, get your group moving. This cannot fail to look natural, you just have to be mindful of the people in the front of the frame covering those behind.

Lessons: people

The biggest challenge when photographing people is to give confident directions. In order to get the best from your subject, they need to feel comfortable and confident in you, the photographer. Not many people really like being photographed, and most will generally shy away from the camera, or come to the sitting with a 'grin and bear it' attitude. There is always the exception: some people are natural flirts and will play up to the camera beautifully, making your job very easy. More often though, they will not be sure what is expected of them and will be looking to you.

Generally a level of stage management is involved when trying to capture a strong portrait. Whether you are tying to achieve a spontaneous candid moment or a highly structured pose, being in control and successfully directing the shoot will be necessary.

Practice makes perfect, but as a novice you will have the added pressure of being a bit 'fingers and thumbs' with the gear to start with, as you try simultaneously to control the correct exposure and look for the best composition. It can be a lot to contend with. It's easy to get flustered when things are not falling into place, and your subject may be chatting away or worse feeling more and more awkward, oblivious to your technical and compositional challenges.

Before we get on to the two specific lessons that follow, here's a simple two stage method that I use to get great people pictures:

A good starting point is to decide loosely on the position of your model: head and shoulders, sitting or standing, or full length. This will give you an idea about the amount of space you will need. Then establish and frame your backdrop. Try and keep it plain and uncluttered, and with enough scope to change your focal length. Make sure you have good, even, natural daylight. This will keep your exposures simple and consistent.

Now put your sitter in position. With this simple scenario and your exposure set, you can focus purely on your composition and direction techniques.

top tip
* A two stage method:
frame your background
position your model/s in frame

people lesson 1

a single sitter classic portrait

When starting out, make things easy for yourself by keeping your first few shoots structured and simple. Work with a single sitter, preferably a willing and patient friend, who will quietly let you direct them, without you having to engage in polite small talk. Explain that this is a practice session only and there are no expectations of stunning shots.

Prepare for the shoot by looking at other photographers work that you would like to emulate, there is nothing wrong with taking inspiration from others, and having a few positions and ideas sketched out before the shoot will give you a starting point. Aim to come away with a handful of successful images, full face, head and shoulders, sitting and standing positions.

Allocate an hour, when there are no other distractions. Choose a quiet place and use the two stage method previously described to establish and frame your backdrop before putting your sitter in position.

I always start any portrait session by explaining that a shoot is a little like a tennis match; both photographer and sitter need to warm up, there will be many missed shots, and some great rallies when it all comes together. A bit of role reversal can help, and I will sit in shot and show them a few positions to give them an idea of what I expect from them. All shot in daylight studio settings: 80mm f5.6 125th sec ISO 400.

I find it best to start with your model seated, this is less intimidating for the model than standing. Use a stool or box rather than a chair with a back, it's one less thing to contend with in the frame, a few steps or boxes to raise their feet can help, anything to get them sitting naturally and to avoid the 'passport pose'.

Without becoming too dominant or bossy you will need to control the shoot to achieve the shots you want. Finding the right pose and composition isn't always obvious and you will need to tune in and observe very carefully. Start shooting and when you feel the shot is beginning to work, stick with it and tweak the position of the model and your angle until you have it, then break for an alternative position and build up the next sequence of shots in the same way.

Avoid moving around and about your model, stay directly in front and instead move your model within the frame; you want to avoid losing the framing of the backdrop, and by limiting the variations, you can concentrate solely on the model's position and interaction in frame.

If you find yourself randomly shooting away but have lost connection with the visual essence of the frame then stop, it's bad practice to shoot aimlessly in the hope of getting something. You must tune in and re-connect, no matter how much pressure you are feeling to get something. Remember your crop cards basics, look and take notice of each change in position and how it is improving or weakening the frame. It's better to achieve one well structured frame than lots of weak attempts. Above all, remember it's okay to take your time. If it's not working don't panic, stop and say it's not working and that you are going to try something else.

Communicate clearly with your subject. Go for tweaking, rather than complete shifts or change of position. Be clear with your instruction: specify left and right, up or down, forwards and backwards. This may sound obvious but when you are looking and keeping your eye fixed on the viewfinder, it's not easy to relay exactly how your model should move. Be aware that the camera body in front of your face may muffle your voice, so speak clearly.

lessons: people

Although this may feel like quite a rigid way of working, remember that we are learning about how to direct people and ultimately the shots should look entirely natural and effortless.

As you gain more experience you will build on your repertoire and will have a few fall-back composition ideas and techniques up your sleeve. It will become easier for you to put people into position, as you will be clear about what you are aiming for.
All shot in daylight studio settings: 80mm f5.6 125th sec ISO 400.

people lesson 2

one group, different ways

In this lesson we will look at the different ways you can approach photographing a group. I have chosen a large extended group of boys, all brothers and cousins. The brief was to capture the entire group informally on location, and offer something a little more interesting than the standard format group and head shots. The boys were great to work with and were all up for getting involved.

I went on to include individual family groups, sibling groups and individual head shots, giving the family a wide choice of shots. With a shoot like this you are always faced with the constraints of time allowed and how much the subjects are prepared to work with you.

Having achieved a nice (but boring) traditional group shot, the boys had sat in close quarters for too long. Without too much encouragement on the command "FIGHT!" this well-tempered scrap broke out and a fun sequence of shots followed. Don't allow this to get out of hand – as the photographer you must control the shoot to get the shots you want. 50–70mm f8 500th sec ISO 400

This shot is stage-managed in as much as I had to arrange them in a tighter group to get them all together in frame, but I hope the result is natural as they wade through the water towards me. It didn't bother me that not all their expressions are perfect, but getting a wet bottom did!
35mm f8 500th sec ISO 500

If you are faced with a larger, more formal group, the challenge is to get everyone looking at you and all looking good at precisely the same time. If there are one or two people who do not look their best in the final frame then I will swap them in post-production. This is only possible where the heads, bodies and background are easy to cut around in Photoshop. It's a cheat, and best avoided, but a neat solution when you are dealing with fidgety, naughty boys. You can see the 'before and after' effect of this technique used in the shot of the boys leaning against the wall.
30mm f8 200th sec ISO 400

The long flight of steps give a good perspective, but it was difficult to get the balance of seven people right on the confines of the steps – the youngest is a little lost at the back and the full sun is casting harsh shadows.
50mm f8 500th sec ISO 200

fashion and beauty

The opportunity to work with beautiful models, clothes and make-up is always a photographer's dream. A more stylized and experimental approach can be taken, where the boundaries are pushed.

However there are usually constraints: it is often a requirement that the clothes need to be shown very clearly – the cut, colour and detailing – and this may challenge your composition, yet the overall image must still work and have that essential 'fashion feel'.

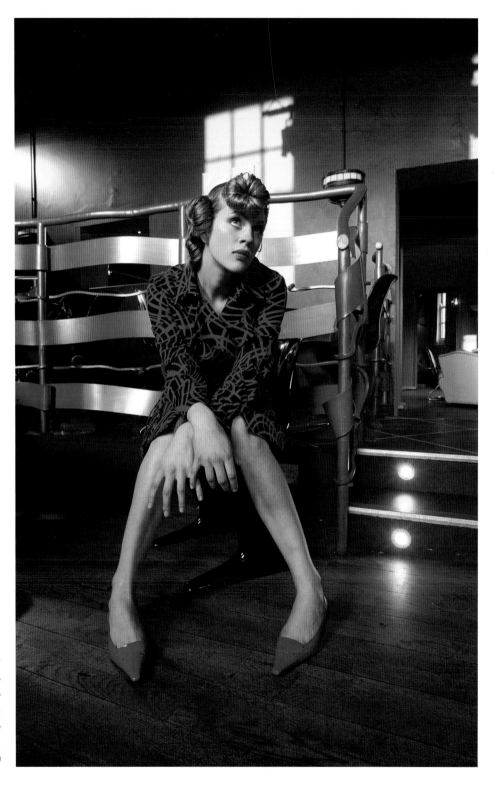

END OF THE DAY

This was the last shot of the day and you can see the evening light that was coming through the window reflected on to the back wall. This bathed the room with a warm, golden light. The red railings perfectly echoed the wavy red lines in the dress, shoes and hair.
24mm f8 1/5th sec (tripod) ISO 800

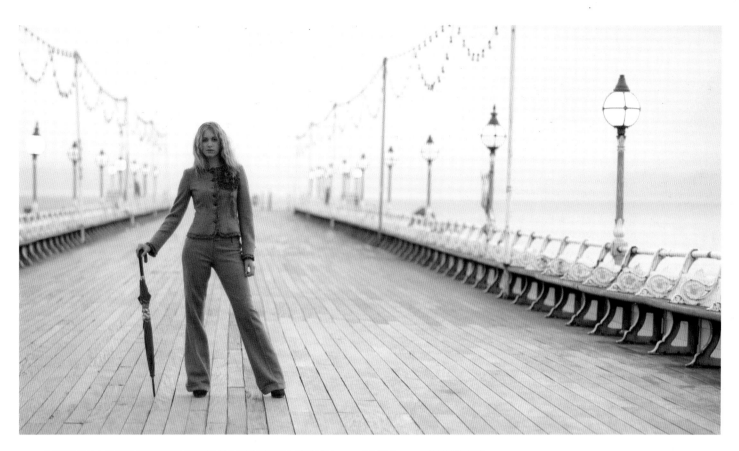

DUSK

This beautiful Victorian pier was the perfect backdrop for this solitary model. I purposely arranged to be there at dusk so the lights would be lit. It's tempting to place everything centrally, but the shot is stronger for having the model off-centre. The umbrella prop also helps to strengthen her pose.

130mm f2 30th sec ISO 400

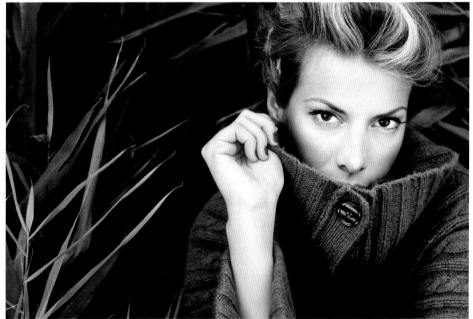

IN THE GREEN

Colour plays an important part in composition. The location here was unpromising but some green foliage gave me the solution.

100mm f5.6 250th sec ISO 200

the nude

The nude has always been a favourite subject of artists and photographers. Stripped bare, and sensitively lit, the beauty of the human form is a wonderful subject to photograph. Sensitivity is the key to achieving beautiful images.

I would draw a distinction between the classic 'fine art' nude and erotic glamour, or boudoir style shooting. Personally (and I don't think I'm alone here), I am not interested in the typical topless glamour shot – brightly lit, chest thrust forward, topped with a cheesy smile. I am always looking for a more sensitive approach with creative lighting or unusual settings, and a much less overtly sexy pose.

If you are going to attempt a nude shoot, whether your subject is a professional nude model, a friend, partner, man, woman or total stranger, it must be sensitively approached. It is not easy for anyone to stand naked and vulnerable in front of a camera.

Let's be honest, to look good naked with confidence, and by good I mean 'model good', you have to be in great shape. In the real world most of us are not model perfect. We all

BUMP
A bump shoot is always lovely to do, and the classic 'Demi Moore/Annie Lebowitz' side on pose is hard to beat.
50mm f4.5 60th sec ISO 100

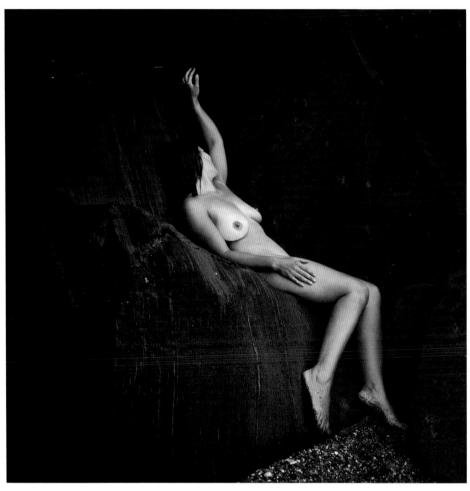

RECLINED ON ROCKS
The angular rocks created a cradle for the model to comfortably recline. We have given this a very warm tone in production to flatter her skin tone.
35mm f11 (I wanted a large depth of field to render everything pin sharp) 60th sec ISO 1000

accept our wobbly bits, and we learn how to disguise them, to live with them or even to love them. With nude work, more than any other genre, you have a responsibility to tread carefully and show the model in the best and most flattering light. No matter what age or shape they are, you want the sitter to feel good about themselves, both during the session and with the final results.

A level of trust between photographer and model must be established before the shoot. I find it helpful to run through with the model and/or client exactly what to expect during the shoot, to reassure the model. Ask what look and style they are hoping to achieve. Discuss the location: if you are outside then you will need to plan, and make sure you are not breaking any indecency laws. Ask the model to bring a robe, or provide one yourself. Is the model comfortable being totally nude or would they prefer some cover? Ask them to remove

BEAUTIFUL BLUES

The natural rock formations echo the lovely curves of the female form, not very comfortable for the model but it should be all about getting the shot.
24mm f11 60th sec ISO 1000

any tight underwear a few hours before the shoot so that no marks are left on the skin. It's very difficult to remove indentations, and worse, strong tan lines in post-production. Define where all the boundaries are before the shoot.

At the shoot, the moment of disrobing is always awkward for the model and for the photographer but I find once past this stage, having discussed and pre-planned the shoot, very quickly the model and photographer should be entirely comfortable. Once the model is naked or semi-naked in front of the camera, they generally find the experience very liberating and will be quite relaxed. I often use sheer fabric to shoot through, as having everything on show is not necessarily the best look, and the model may feel far more comfortable if they are less exposed, certainly to start with.

SIMPLE BUT SOFTENED SETTING
I shot this nude in an empty house, but the sofa was tatty and I needed something softer to set the model against, so I took down all the net curtains – the shot wouldn't have worked without them.
24mm f8 125th sec ISO 400

WITH THANKS TO BERT STERN

This is a Marylin Monroe/Bert Stern-inspired shot – I have no problem with plagiarism. It's a good idea to look at other people's work for new ideas and incorporate these into your shooting. It's unlikely that you will replicate too closely as so much depends on the light, setting and final processing of an image. In this shot, a fan held the sheer fabric against the model's body.
40mm f8 30th sec ISO 200

BARE BOATING

This was one of many shots I needed to achieve for a naked charity calender. The boat was heavy and it was a challenging pose for the girls. I wanted the water line just below their bottoms, so we had to manoeuvre to get that right, and by back lighting them and underexposing slightly, I was able to offer a more discreet naked image.
105mm f5.6 60th sec ISO 400

events

At any event, be it a wedding, a party, a cultural festival or a sports fixture, there will be many great 'photo opportunities'. Whether you are there in an official capacity or simply as a casual snapper, you will want to capture the key moments that sum up the event.

Pre-planning is a must, and a list of the proceedings will help you to keep track and ensure you don't miss any key moments. The last thing you want to do is miss the blowing out of the birthday candles, the confetti shot, or the winner crossing the finishing line. This may take up a moment or two of your time, but the busy girl will put in the effort in pursuit of perfection.

♡ The last thing you want to do is miss the blowing out of the birthday candles, the confetti shot, or the winner crossing the line

Aim to come away with a collection of images that tell the story of the day. Don't forget to observe the detail; often these incidental moments are more telling, giving depth and insight, and will complete the overall collection of images.

LONG LENS

A telephoto lens is essential for covering sporting events, but bear in mind that it is difficult to hold a long, heavy lens steady and follow the action without camera shake and potentially disappointing out of focus shots. This common problem is a good argument for getting off auto, as your camera may inadvertently not select a high enough shutter speed. To begin with, try using shutter priority mode and selecting a fast, 500th or higher, shutter speed. 250mm f5.6 500th sec ISO 400

weddings

A wedding is really three separate events: the marriage ceremony, the reception and the party. It's always such a lovely happy day and offers so many great opportunities for the photographer. To give the happy couple some beautiful shots of their big day is always appreciated, and fun to shoot for them, but it is quite another thing to be there in an official capacity. That comes with a huge responsibility, as not 'getting it' is not an option. As a keen novice snapper, you may be asked to be the official photographer; be very careful. To try and tackle everything that a wedding day will present is a 'big ask'. Only offer what you feel confident you can deliver.

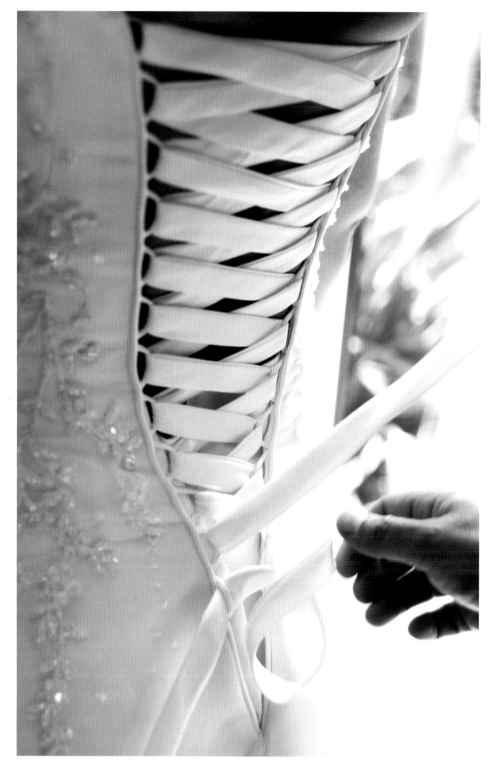

BRIDAL DETAILS

The bride getting ready is always a popular shot to achieve. Clear a space in the brightest, least cluttered room for the bride to stand while all the finery and finishing touches are done – that way you are giving yourself the best possible chance of getting some nicely lit shots. Come in close to capture the all important detailing on the gown, and use a reflector or bounce a little flash into the room to help illuminate it.

60mm f2.8 125th sec ISO 800

If you can successfully cover a wedding from start to finish, then you can pretty much tackle anything. Over the course of the big day, expect to have every sort of shooting situation thrown at you: still life set-ups of the bouquets and pretty detail shots of the bride's gown and finery; classic portraiture of the bride and groom; the groups – always being ready with your photographer's sixth sense to capture key, fleeting moments – with maybe a bit of architecture and landscape work and some crowd control techniques thrown in for good measure. Often you will be shooting in challenging and uncontrollable lighting conditions. Be prepared for no natural light at all, for rain, wind or bright midday glare. And everything must be achieved within a very limited

RED BRIDESMAIDS

This was a military wedding on an army base and it was raining, so I was struggling with location and conditions. Turning the negative to positive, I used the large expanse of the wet parade ground as a backdrop for the girls. I clambered up onto a wall to lose the perimeter fence and got the girls to skip back and forth.
50mm f8 200th sec ISO 400

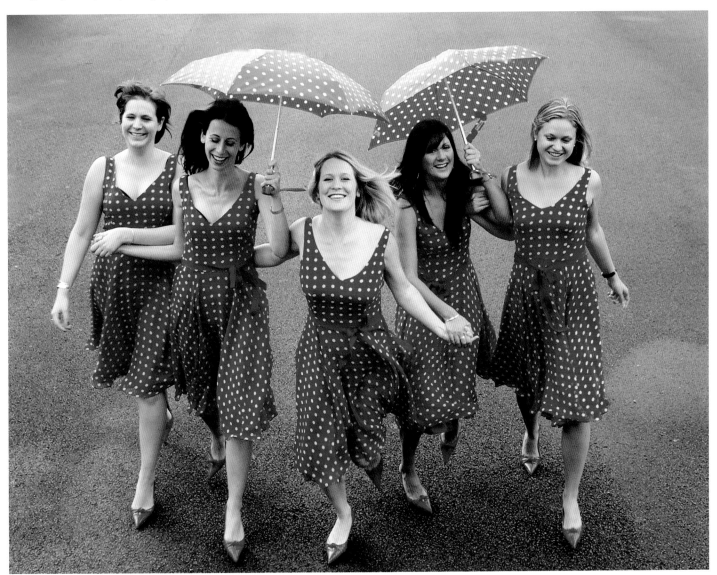

FATHER OF THE BRIDE

The father giving away the bride is an important image. I was lined up for a formal shot and was blessed with a spontaneous moment between them both – you can't plan for these shots but you should be prepared, in position and camera set and ready, to take advantage of the moment.
85mm f5.6 125th Sec ISO 400

window of opportunity. It's not enough to turn your camera to auto and snap away in the hope that you will capture it all.

I don't say all this to put anyone off shooting a wedding, it can be a wonderful, creative and fulfilling experience, but I have often seen photographers out of their depth, and we have all heard the stories of when things go wrong. Don't put yourself in a situation that takes the pleasure out of

your photography. No matter how casual the arrangements are, there is always high expectation of the wedding photographs.

If you are asked and are feeling confident about the responsibility, for your first time suggest a limited service. Draw up a schedule with the couple so everyone is clear what is expected of them. Always do a full reconnaissance of the venues you will be shooting in. Now is not the time to play

WEDDING GROUP

The shade and the five steps large enough for two hundred people make this work. You will need confidence to direct people into position. Only attempt this shot if the location is suitable and time allows. 24mm f11 60th sec ISO 400

BRIDE AND SISTER

I noticed the bride and her sister share this tender moment. A reflector would have improved the shot to lighten the shadows.
80mm f4.5 60th sec ISO 400

your 'busy girl' card – there is no escaping the fact that planning a wedding shoot takes a bit of time. By agreeing to cover fewer shots, you can impress, rather than risking trying to offer it all. If you are successful you will feel confident to push yourself a bit further.

parties

Everyone loves a party, especially us busy girls, and there are always lots of smiles to go around. If you want to elevate the party snap into something more inspiring, then you need to take yourself out of the party and become a voyeur, seeking out smaller groups, anticipating the punch line of someone's joke or finding a great vantage point to shoot the party in full swing. At children's parties, getting on the floor and shooting from a child's perspective will give you the winning shots, and don't forget the balloons, cake and candles.

IMPROMPTU GROUP
This group shot was requested off the cuff, but even so I took the time to structure it for them to make it a little more interesting than a hastily gathered huddle.
24mm f5.6 100th sec ISO 400

♡ I like to work through a room, shooting spontaneously, grabbing shots and capturing an element of surprise

WOMAN AT A PARTY

It's a good idea to have a mix of formal and informal candid people shots, to give a varied collection and flavour of the party.

35mm f5.6 125th sec ISO 400

Low light will be your biggest challenge. At an evening event, once the daylight has gone, you will be forced to rely on the available artificial light and your flash. If there are any specific people shots required, then aim to achieve them before you lose the light. Often when the mood lighting of the party and the twilight balance each other, you can get the best shots.

While it's a great idea for the host to have a candle-lit dinner party, it will create problems for the photographer, and there will be occasions when you will be forced to use flash as the main light source. Where possible and for a less harsh flash-lit image, avoid direct flash and try to bounce or diffuse the light from your flashgun.

Working at high ISO and slower shutter speed will record as much of the available light. Movement blur and digital noise will inevitably be a by-product in some of the shots, but I think this is a good payoff. I would rather capture the mood lighting and true atmosphere of the party rather than having lots of sharp, harshly-lit flash images. A dancing couple is often best depicted with motion blur, rather than a freeze frame moment. Be creative, think outside the box and push the boundaries.

I like to work through a room, shooting spontaneously, grabbing shots and capturing an element of surprise. Most people will shy away when you point a camera directly at them, but I find that if you do catch them unaware and then shoot again, they will often respond favourably. You have to be prepared to put yourself out there, in amongst the action.

Don't forget to cover the shots of the venue, the food and drinks, and the hosts. These will tell the story. And last but not least, if you're there in an official capacity, don't drink and drive your camera.

KIDS' PARTIES

To really capture the fun and mayhem at a children's party, get down on their level and join in with the party games.

35mm f5.6 125th sec ISO 800

cultural events

Community events and festivals can range from fireworks displays to agricultural shows, and sometimes include a competition or specific element that you can treat a bit like a sporting event. Aim to tell the story, think laterally and try to be original. Some events occur at night, with all the challenges that night-shooting presents.

BARREL BURNING
The only light illuminating this subject is the fierce fire of the burning of a tar barrel (a bizarre ancient rural festival). I struggled with the low light and pushed the limits of my gear and exposure.
24mm f2.8 200th sec ISO 1600

sporting events

There is always added pressure when shooting a sporting event, lest you miss 'the money shot'. The action will generally be moving fast, and there will be other photographers vying for position. It's a good idea to ask yourself before the event starts, which are the shots that you 'have to have'. The winner crossing the line? Or the loser's dejection? The prize giving? What is the story you want to tell?

Can you find a new perspective, something different or unusual that perhaps no one else would have thought of? The spectators? The venue?

SPEED AND SPRAY

*A very fast shutter speed not only froze the boat in mid air but it also captured the spray and very heavy rain.
100mm f4 4000th sec ISO 1600*

AFTER THE ACTION

Even after the action is over, there is always a photo opportunity. One of my favorite shots of the day was of this quiet little foreshore with all the boats and oars, post race.
100mm f8 400th sec ISO 400

RIB EYE

A wonky horizon can make or break an image. Also consider where the horizon cuts through the composition – it was critical in this shot that the wake boards, the steering wheel and the engine were not being cut in half. This sort of attention to detail will pay dividends. 70mm f4.5 800th sec ISO 1600

nature and wildlife

To try and sum up this huge genre in words in a few brief paragraphs would be banal. From the minutiae of a tiny insect seen through your macro lens, to the broad expanse of a wild landscape, the wonder of the natural world gives the photographer endless opportunities to capture.

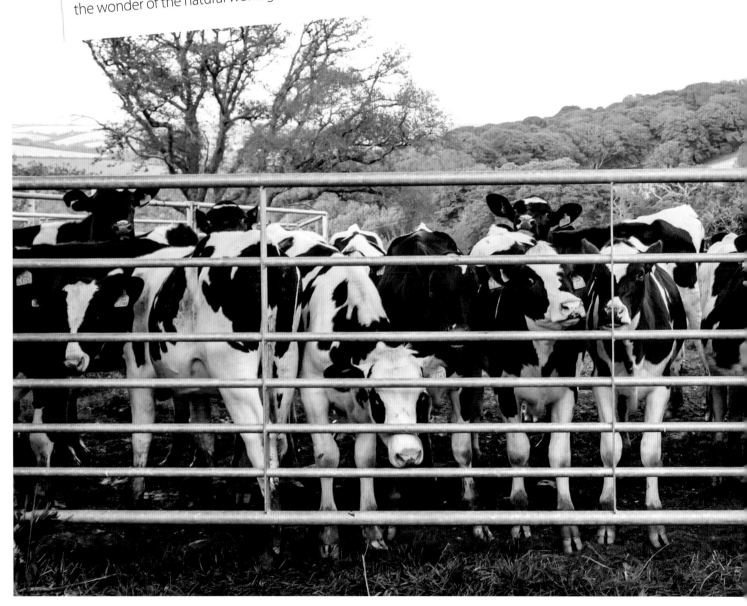

♥ wildlife photographers are specialists – but I think most genres can be attempted if you apply the basic principles of good working practice

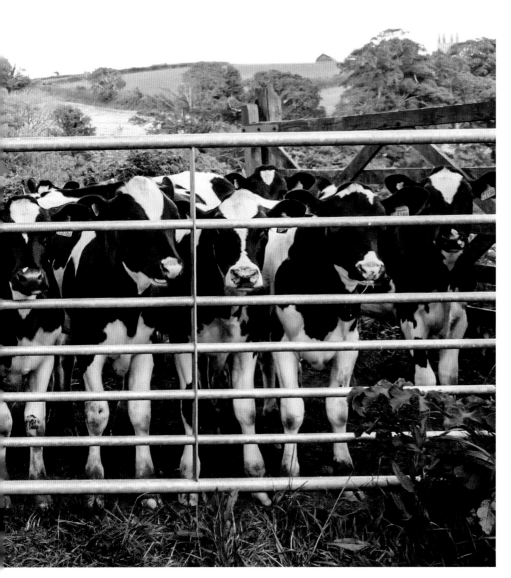

COWS AND GATE

I passed this gate driving home one evening and couldn't resist these young cows looking through it at me. Always have your photographer's head on if you want to build a body of work. I took particular care to show their little feet poking out underneath the gate.
30mm f8 30th sec ISO 800

ALIEN FLY

This little common housefly is given alien status with a prime 60mm macro lens. It's worth having a macro in your kit bag, as it's great to be able to achieve this sort of detail in your work.
60mm f6.3 60th sec ISO 800

TULIP
This shot is all about the intensity of the colour and the curved lines of the tulip petals, which draw your eye in.
60mm f2.8 250th sec ISO 100

SEAGULL

I exposed for the ultra bright white feathers, but it is a shame to have chopped through the gull's feet with the horizon. However, this was my favourite frame, showing the magnificent wing fully extended.
24mm f6.3 2000th sec ISO 400

animals and pets

'Never work with children and animals'. Domestic or wild, our furry and feathered friends are always a challenge to capture.

You will need knowledge of your animal and a good measure of patience. An uncontrollable and excited puppy may be impossible to capture: if you are down on the floor with them they are likely to be bouncing all over you; and put up on a table you risk them falling. This shoot is best attempted when they are worn out, calm and sleepy.

HORSE
I chose this hilltop location as I wanted to use the clear uncluttered expanse of sky as a background for the shoot.
66mm f5.6 2000th sec ISO 1250

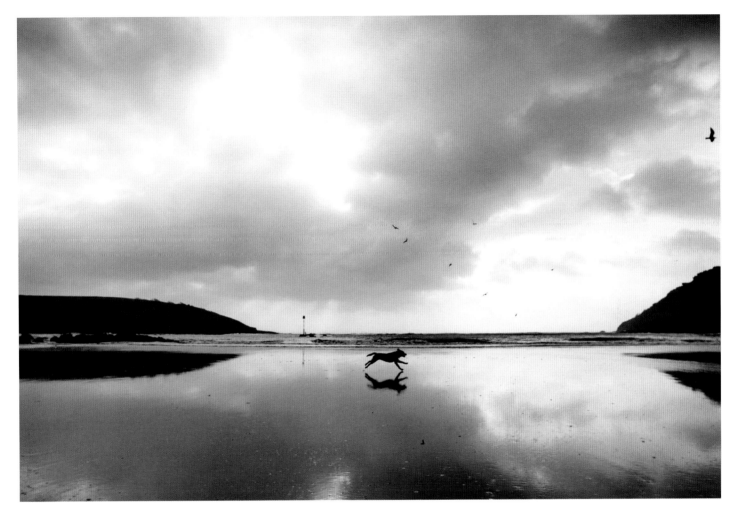

RUNNING DOG

This shot works as the dog is captured full stretch so his shape is perfectly delineated. The reflection, birds and black and white treatment all add to its moody atmosphere.
24mm f8 250th sec ISO 800

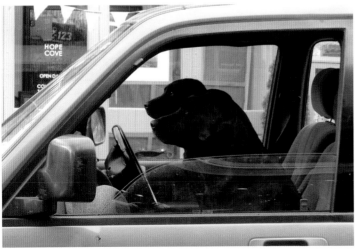

DRIVING DOGS

I shot this on auto on my 'happy snapper' camera – the perfect camera for those classic grab shots.
Settings on auto

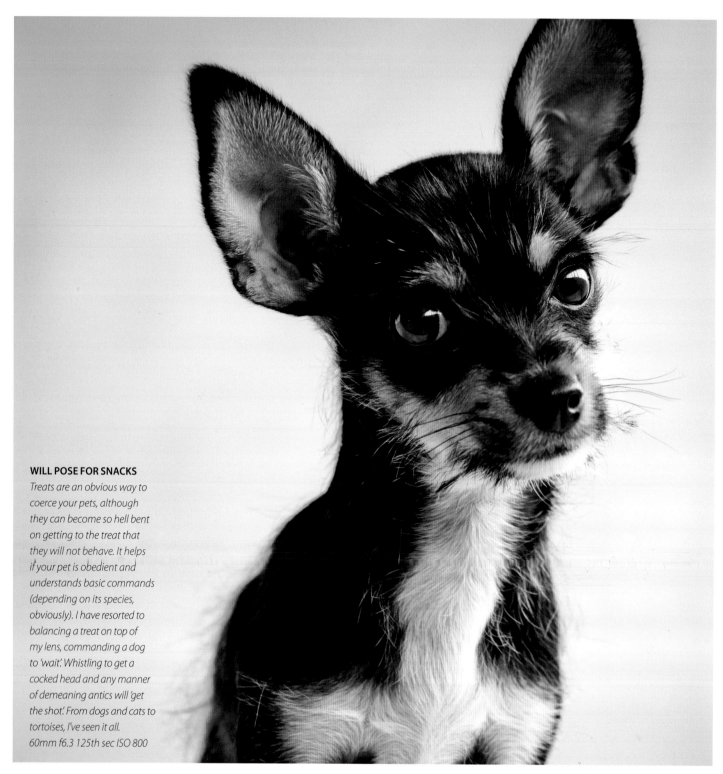

WILL POSE FOR SNACKS

Treats are an obvious way to coerce your pets, although they can become so hell bent on getting to the treat that they will not behave. It helps if your pet is obedient and understands basic commands (depending on its species, obviously). I have resorted to balancing a treat on top of my lens, commanding a dog to 'wait'. Whistling to get a cocked head and any manner of demeaning antics will 'get the shot'. From dogs and cats to tortoises, I've seen it all.
60mm f6.3 125th sec ISO 800

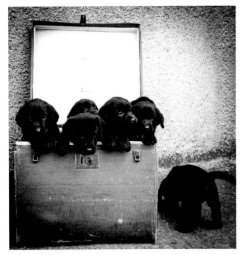

PUPPIES IN A TRUNK

There were twelve puppies in this litter, presenting a near impossible task – I needed a bigger trunk.
30mm f5.6 250th sec ISO 200

SHOW HUNTER

I came from a really low vantage point to exaggerate the beautiful shape of his neck.
5mm f5.6 125th sec ISO 400

landscapes

Landscape photography is a broad term, and in discussing this genre I am referring to and including water and buildings in the landscape, and of course the most important element, the sky. The sky because of course it offers important content and the 'stage lighting' to the surroundings that as a landscape photographer you will aim to capture.

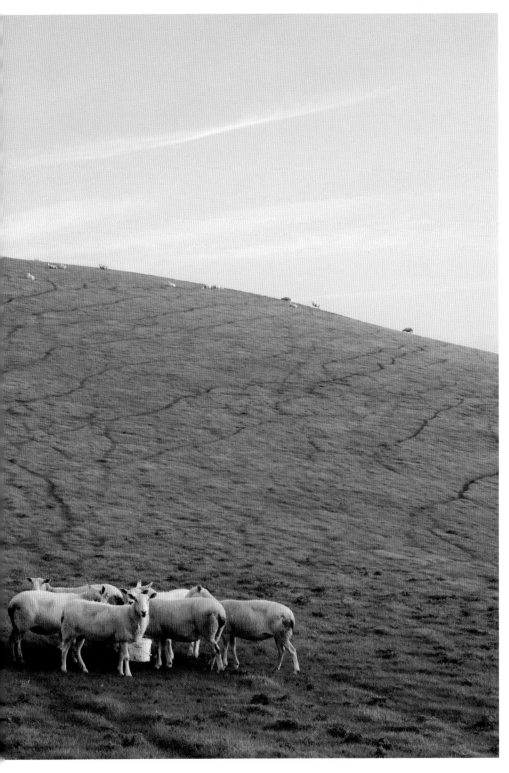

From the 'traditional' scenic vista to the intimate study of a tree's bark, the pursuit of making a beautiful landscape image brings us into close contact with our surroundings and has always been a powerful draw for both photographers and artists. Sometimes the vista before us will be so beautiful that on a good day 'shooting from the hip', so to speak, is all that is required to make a beautiful landscape photograph. Perfect

> *the pursuit of making a beautiful landscape image brings us into close contact with our surroundings*

if you're a busy girl with a million different pressures on your time. But this is not what really clever landscape image making is all about. If we are doing it properly we need to give due time and consideration to our subject to reveal the wonder it can offer. Planning and preparing to take advantage of good light, always observing attentively, exploring the space and waiting for perfect conditions will create the perfect representation of the scene before our lens. As you will see in the landscapes lesson that follows, looking beyond the obvious and patiently waiting will reward you. So tune in.

HILL SHEEP
The dew on the grass delineated the sheep tracks on the hill and the small huddle of sheep bottom right give the frame interest. I attracted their attention by tapping a lens cap on the leg of my tripod – even sheep should be well posed.
50mm f11 10th sec ISO 200

Lessons: landscapes

It is important when setting out to achieve a beautiful landscape image to approach it with a photographer's mindset. Don't just take your camera out on a walk with friends and family and hope to achieve that stunning shot on the way. You may get lucky if the conditions are right but it is better to set forth on your own with a plan and one aim in mind – a bit of 'me time' for the busy girl.

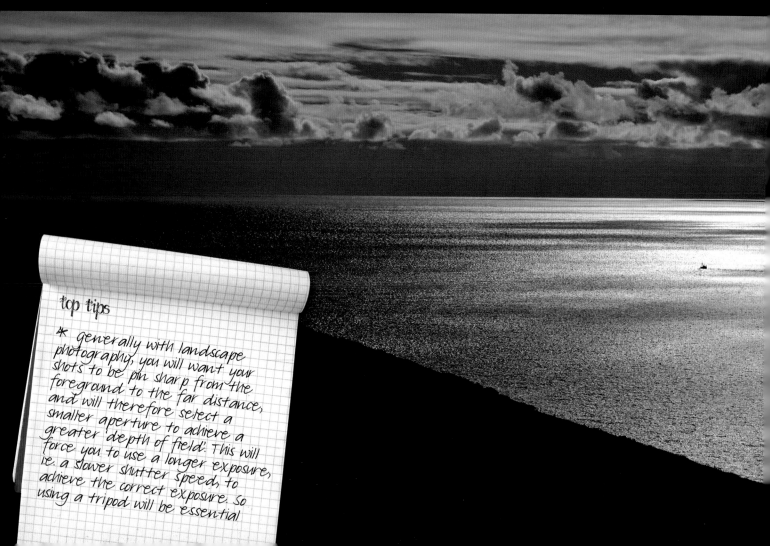

top tips

* generally with landscape photography, you will want your shots to be pin sharp from the foreground to the far distance, and will therefore select a smaller aperture to achieve a greater depth of field'. This will force you to use a longer exposure, i.e. a slower shutter speed, to achieve the correct exposure. So using a tripod will be essential

Successful shots are often the result of many attempts at the same location; don't expect to get it right first time. Re-visit to find the best vantage point at different times of the day or year, when the light, colour or weather may make the change that will radically alter the entire look and feel of the image.

Whether you are shooting a wide and wild panoramic vista or an urban industrial landscape, you will need good lighting to illuminate your scene. Early morning and late evening, 'the golden hour' offers the best light. Don't dismiss bad weather days as this is when you will encounter the most dramatic lighting, particularly as weather fronts move through at the edge of storms, for example, when skies can be spectacularly heavy and dramatic and the land washed clean and sparkling with passing rain. I know one photographer who only shoots on grey, dull days as this best suits his particular style and post-production techniques.

We have touched on the rules of composition (and breaking them), but it is worth familiarizing yourself with them specifically for landscape photography as this is a good starting point when you are struggling to bring your composition together, selecting the elements to include or exclude within your frame.

classic postcard view of a scene

This stunning location on a beautiful day cannot fail to impress. Perhaps if it was taken at the 'golden hour' rather than in the middle of the day, it could have been improved, although the bright light has rendered the predominant blues and greens of the scene well.

It is, however, simply a record of a beautiful location and I gave little consideration to the composition, other than where to stand to give me the widest and best vantage point from the cliff path. My camera was on an auto setting, and the mid-range depth of field that the camera selected is okay, but at enlargement would not bear scrutiny. Although the image falls into classic 'rule of thirds' composition, this is what I would classify as a postcard scene, not a challenge to achieve artistically speaking. 24mm f8 250th sec ISO 200

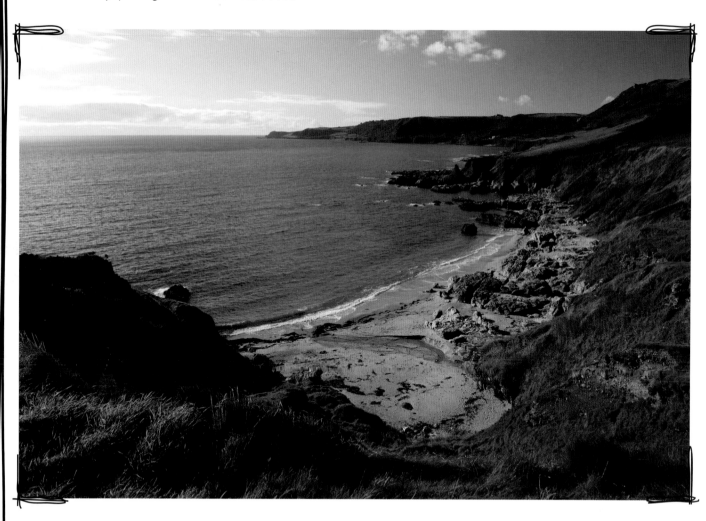

Walking down onto the beach revealed this small cove, with a waterfall in the distance. A tripod is an essential piece of kit for landscape photography and without one this shot would have been impossible to achieve. Putting the camera on a tripod allowed me to use a slow shutter speed; this smoothed the surface of the water, getting rid of distracting ripples. I also used a polarizing filter to cut down the reflected light from the water, to see through the surface to the light sandy seabed. The polarizer also had the effect of increasing the saturation of the blue sky, making the clouds stand out against it.

Once I had decided to use a slow shutter speed to blur the water, my camera settings were easy – ISO 50 to give me the best detail and finest quality, f16 to keep everything in focus from foreground to background and cut down the light enough to allow me to select a slow shutter speed. This resulted in 0.8 second to obtain the correct exposure. If I had wanted an even slower shutter speed I would have had to use a ND (neutral density) filter in front of the lens to cut down the light even further.

The sun was going in and out behind the clouds and often I would wait for shaded light to reduce the contrast in the scene, however in this case direct sunlight was working better, bringing out the texture in the rocks and making the water appear more luminous and transparent. I shot several options in varying lighting, so that I could assess the images more carefully when I got home and downloaded them onto a computer.

simple is better!

Although I was really pleased with the shot of this small cove with waterfall – and it is a progression from the 'postcard scene' – I was looking for something more moody and dramatic, so I continued around the rocks in order to get closer to the waterfall.

Moving in closer to the waterfall allowed me to start simplifying the scene in front of me. By removing distracting elements from the image, the waterfall really starts to become the focus of the shot. The eye will always be drawn to lighter parts of an image, so by letting the rocks and sky go dark, the eye is drawn naturally to the waterfall. Unlike the previous shot, I have waited for the sun to go behind a cloud, shading the scene to give me much softer, more even light and lowering the contrast in the image. 35mm f22 1.3 sec ISO 50

This is my favourite shot from the shoot. It's good but I still feel it lacks that 'wow factor', and the location really was incredibly beautiful. I intend to go back after heavy rain when the fall will be more powerful, and also on a falling tide when the water is not quite so high, so I can get closer and shoot from a different angle. It often takes many attempts to get just the right shot and unlike painting there is no option for artistic licence, you really do have to plan for the most favourable conditions. Chance definitely favours the prepared mind. 50mm f16 1.3 sec ISO 50

travel and holidays

On our travels we encounter cities, landmarks and architecture, people, culture and food. Your travel images should conjure up a sense of place. Taking all your gear on your travels is not always an option and I know when I go on holiday I am glad to leave my full kit at home. This is when a compact camera really comes into its own.

BLUE WALL

Not an obvious holiday shot, but the colour combo and distressed paintwork was hard to resist.
35mm f5.6 60th sec ISO 200

DECK CHAIRS

Highly reflective snow can be a challenge – meter manually or use your compensation button to push your exposure by a half a stop or so.
50mm f14 320th sec ISO 100

BICYCLES IN BELIZE

This is actually a shot of me and my friend on holiday in Belize. I set my little 'happy snapper' compact up on a rock, set the timer to shoot us under this beautiful tropical palm on our rickety hire bikes. Mine's pink.
Settings on auto

RED SHOP

I took great care to frame this shot using the red painted lines as a guide. The patch of blue sky and the blue door work because the red extends across the top of the frame, holding it all together.
35mm f5.6 125th sec ISO 400

JETTY AND STEPS

This shot was taken many years ago and I spent hours struggling to get the frame right. It was important to have the line of the step coming into the bottom left-hand corner, to keep the bow of the far boat and the writing on the sugar sack in view, and to keep the horizon straight – tricky on the confines of a jetty. I didn't get the exposure completely correct, but I still love the shot.
14mm f11 15th sec ISO 400

SUMMER

The low sunlight is causing a little flare, but in this shot it adds to the dreamy, summery feel. A lens hood can cut down the flare, but I find it more effective to use your hand or a piece of card to cast a small shadow over the front of your lens.
40mm f8 40th sec ISO 400

still life

A simple definition of still life is the recording of inanimate objects, but really it's anything from the proverbial bowl of fruit shot from a fine art perspective, to a flat shot for a commercial product, or an interior of a room.

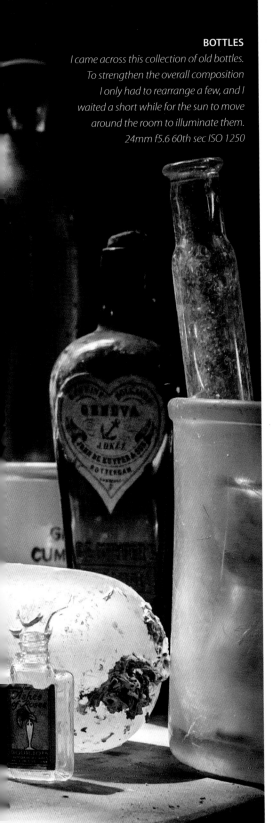

BOTTLES
*I came across this collection of old bottles.
To strengthen the overall composition
I only had to rearrange a few, and I
waited a short while for the sun to move
around the room to illuminate them.*
24mm f5.6 60th sec ISO 1250

CHEST
This impressive boat builders' tool chest was an interesting still life subject, I like the mix of old and new. I came in close using a wide angle and lined up the front edge of the box to fill the edge of my frame.
24mm f5.6 60th sec ISO 1250

From a novice's perspective, still life is a great place to start improving your skills. There are far less variables than there are with portraiture or landscape, you have complete control over the situation, and you can take as long as you need getting used to your gear and experimenting with different exposures. You don't need lots of equipment: daylight from your window, or a few ordinary lamps, some white or black card to bounce or absorb light and a few props to create your own work of art.

As a starting point, pick out all your most favourite pretty things – perfume bottles, a piece of jewellery, mix in a few vintage pieces – photographing them will give them a new dimension. Much tweaking of

position will be required to find the best angle and arrangement of your objects. You need to think extremely creatively in order to capture your subject in an interesting and engaging way.

More often than not though we simply need to record a product, whether we are selling our clothes, perhaps on Ebay, or shooting images for our blog. We often just need a good quality, clear photograph that sells the item or the story. There are some very simple solutions that don't involve going out and buying studio flash kits with umbrellas and product tents, although this gear is useful if you are shooting on a larger scale and you need a totally controllable and continuous light source.

food, product and interiors

Despite the obviously wide range in subjects, food, products and interiors share the advantage of putting the 'still' in still life, giving you plenty of time to work out how to photograph them to best advantage without having to persuade them to stay put. Your desired results will be different, depending on whom your photographs are for.

food

Simple food photography is very easy to achieve with a shallow depth of field and a macro lens. Bear in mind you will be up very close, so the success of the shot will be defined by finding the best angle. Food that has sat around on a plate for too long can quickly look unappetizing, so make sure you have your set-up ready to go as soon as the food is plated up.
Strawberry: 60mm f4.5 60th sec ISO 200
Chips: 60mm f5.6 60th sec ISO 200

product

A simple solution for photographing a small product is to buy a large piece of white card to create a 'cove', place a table in a bright area against a wall, and preferably use natural daylight, without any direct sunlight. Bend the card so it makes a 90 degree curve, but don't create a fold; pin or use masking tape to attach one edge to the wall, and secure the other side with tape to a table. This will give you a continuous uninterrupted background. Place your object in the cove, a reflector can be used to bounce light onto the subject and lighten up any dark areas or shadows.

♡ If light levels are low then place your camera on a tripod and use a long exposure

Make sure your camera flash is off and turn off any other lights in the room. If the light levels are low then place your camera on a tripod and use a long exposure. Your product won't move so there is no danger of blur, and the long exposure will record all the available daylight.

Most people by default tend to stand and shoot from above but I find in general it's better to stand back, select a slightly longer focal length and shoot from the same level as the product. Fill the frame with the product, or give yourself a few options: square, panoramic, landscape or portrait. You will find that the negative space is just as important as the product.

BAG: LIFESTYLE AND PRODUCT SHOT

Most products are shot on white backgrounds as this is the most versatile for publishing in print or on the web. Often the product is 'cut out' in Photoshop in post-production. The product can be dropped onto or into another background or onto a page with text. Here you can see the same product shot in a lifestyle setting and in a studio setting. Often clients will need both styles to properly promote their product or business. Lifestyle shot: 55mm f8 60th sec ISO 400

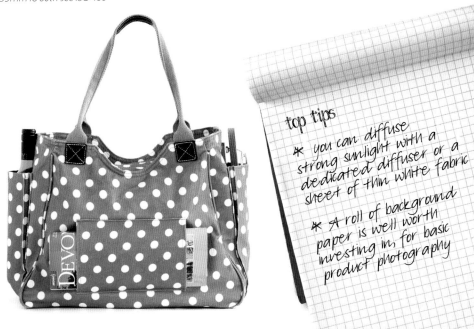

top tips

✷ you can diffuse strong sunlight with a dedicated diffuser or a sheet of thin white fabric

✷ A roll of background paper is well worth investing in for basic product photography

interiors

There are a number of things to consider when attempting an interior shoot. Standing in one corner of the room with a wide-angle lens, may give you a record of the four walls and the ceiling, but it may not give the look, feel and atmosphere of a place. Furniture may need to be rearranged or removed, and clutter tidied away, to open up the space. Finding the best angle and perspective to give a sense of the space is more important. Everyday things such as cables, sockets, rugs, TVs and the like, may be more evident in the shot than to the naked eye, and removing them physically or cloning them out in post-production can really improve an interior shot.

KITCHEN COMPOSITION

Look for a more intimate perspective in a room. I paid particular attention to make sure the window was nicely placed in the corner of the frame, and that the bottom of the cupboard doors exited the frame at the bottom left corner. I placed the lamp on the worktop to give a point of focus and included the edge of the chair to hint at the presence of the dining room. These types of shots should always be included as they offer flavour.
35mm f8 60th sec ISO 400

♡ Furniture may need to be rearranged or removed, and clutter tidied away, to open up the space

SOUTH SANDS HOTEL

The brief was to capture the stunning sea view and beautiful interior of this beach side boutique hotel. This is a classic fill flash scenario. The outside is far brighter than the interior, so to expose correctly we needed to bring the level of light inside the hotel to the same level as the outside, using flash. Balancing the light like this can look a little unnatural because with the naked eye we would just make adjustments as we scan the scene. For a more naturalistic feel, I would generally err on slightly over-exposing the outside scene and making the inside very subtly under-lit. Perfectly balanced, it just looks unreal.
14mm f14 1/125th sec ISO 200

3: post-production

Shooting is the tip of the iceberg. To become an accomplished, well rounded photographer there is so much more involved than simply pressing the shutter. As we have now established, you need to get off auto and drive your camera, and tune in for composition. Now we will look at how to become competent at the final post-production stage.

How much you want to engage with the final process is a matter of choice. Don't feel you have to become a technical master of the digital editing suite. However some knowledge is essential: basic file handling and a few simple editing and processing techniques. These skills will take your work to a whole new level and will enable you to get the most from your photography.

It's so important to share, use and enjoy your photographs. As it is now possible to take so many images, the task of processing and keeping track of them all can easily overwhelm, and before you know it your computer is crammed full of image files that are going nowhere. Do something about it by learning to manage your image archive.

Throughout the next section we will be looking at the equipment you will need: your computer, software and printer. We'll also address the discipline required for managing your growing archive: how to ruthlessly edit so you are only dealing with the pick of the crop, and how to master some simple processing techniques to bring out the best in your image making.

To take your image file, as shot, direct to print with no alteration may be fine, and there are occasions when little or no processing may be needed, but generally an image can always be improved. There may

be much more latent potential within the image than at first meets the eye.

To take the image to its zenith, the ultimate output and true mark of its quality is of a beautifully produced fine art print. This refined process takes a lot of knowledge and there are many stages involved.

If you are looking to attain a level of professionalism in your work then shooting RAW is really the only way to go. This will give you complete control over the final processing, but it will be a much more involved task. Busy girl or not, be prepared to invest many hours in front of your computer.

THE DIGITAL DARKROOM

Many hours are spent in post-production. Photographers working in the digital age have had to master complex post-production skills that were once the domain of the photo lab. Mastering basic techniques is important to take your work to the next level.

For many people this stage is the most enjoyable and creative part of the whole image-making process. But if you're a true hobbyist and don't want to invest hours in the post-production stage then shoot JPEG and learn the basics of file handling and image processing.

computer kit

computers

When you are looking at your computer's specifications, remember that image files, particularly RAW files, and image applications are hungry for memory and processing power. Don't expect to be able to work efficiently or effectively if your machine isn't relatively 'high spec'. There is nothing more frustrating than waiting for image files to open or save. You're a busy girl and you don't need to be twiddling your thumbs while a progress bar inches across the screen.

Before you go out and invest in new hardware, check whether your existing machine is up to the task or could be upgraded. And, may I say, debating Mac versus PC is a matter of choice – they will both do the same job equally well.

For an ideal set-up, you will need your hard drive to be fairly large as image files take up a lot of space. Having a procedure and system for making a stand-alone back-up is crucial – storing your precious image data in only one place is asking for trouble.

Always back-up. Memory is now cheap and external hard drives are the cheapest and most convenient way to do it. Or you could consider 'cloud storage' (online storage, hosted by a third party) as a way to store your image archive, it's great if you have a fast internet connection.

top tip

✳ In order to get the most accurate display from your computer monitor, that is to say to be able to see the colours on screen that will actually be printed, you may need to enlist a professional technician to calibrate it for you. It's a technical minefield, so it may be easier to practise until you 'get your eye in' and come to know what to expect from your screen's performance

software

Most professional photographers use Photoshop, and either Lightroom, Aperture or Capture One. These are the 'industry standard' image processing programs.

Photoshop is incredibly sophisticated and the 'do it all' tool. It requires a high level of expertise to use, and is not designed for a total beginner. Professionals use it specifically to refine their work for print, beauty re-touching and exacting digital manipulation. The majority of the overall process is done in Lightroom.

Programs such as **Lightroom** and **Aperture** are designed for file handling and RAW processing. These programs are more intuitive and easier to use. They will give you a faster workflow for all the selection and editing procedures than Photoshop.

These user-friendly programs are becoming so highly developed that they will give you more than enough post-production capability.

Other software that you may be familiar with includes **Photoshop Elements**, a scaled down and simplified version of Photoshop; **iPhoto**, which comes free and pre-installed on a Mac; and **Windows Photo Gallery**, which is the equivalent on a PC; with many free downloads available online such as Google's **Picasa**. All these are good and adequate for a basic processing, but they have their limitations.

You will need some form of image viewing and editing software even for the most basic actions, in order to adjust final exposure, balance colour and tone, and for cropping and resizing. So shop around until you find the package that suits you.

♥ you will need some form of image viewing and editing software even for the most basic of actions

nerdy notes

operating system This is the interface of the entire computer. Whether you're using Windows or Mac OS, it is important to keep your operating system up to date so you can run current software, and update it to keep on top of developments.

applications are programs or software.

storage The computer has a hard drive, and it's size will determine how much information your computer can store. If you cram the hard drive full it will slow down the computer. External drives are useful for additional storage and backing up files.

ram stands for random access memory. The more the better for image handling, so get as much as you can afford. This will increase the speed of the computer, and the applications will open and run more efficiently.

processor The central processing unit is a chip that performs basic calculations that allow the computer to run. Processing power is a measurement of how powerful this chip is, that is how fast it can do the required calculations. Again bigger is better.

monitor you will need a high resolution monitor. Look for one with a good contrast ratio. Cheap flat screen monitors are simply not capable of displaying a good range of tones. Also, although many laptops come with exceptionally good screens, they are not ideal for image editing. It is difficult to get a truly consistent display, as the screen angle significantly affects what you see.

printers

Many people now share images via Facebook, other social media, or a virtual album on a tablet or computer and the image is never committed to paper, which is a shame. If an image is worthy then it deserves to be printed, this forces us to really look at it properly.

Quality printing is a skill. Many professional photographers insist on making their own prints and are masters at it. But many more outsource this specialist skill to a lab or printer. Outsourcing is a good idea as there are now many affordable and convenient print services available online. Of course quality will vary, and if you send in a badly processed file then expect a poor quality print to be returned.

If you are prepared to pay for the additional service of a print technician then nurture a relationship with a professional lab and let them handle all your post-production and printing needs. You may have very particular requirements for how you want your finished print to look regarding tone and colour and such. Your printer would need to know this to interpret your ideas correctly, as there are a million and one ways to print an image.

If you are going to attempt your own printing at home, you may struggle to achieve prints that look the way you want. My advice when starting out, is to keep it simple and eliminate as many 'what if' scenarios as possible. For example, use a good quality photo printer with the inks and paper it was designed for. Yes, you can get cheaper inks and cheaper papers, but are the colour profiles going to match? Also, avoid adjusting the colour settings on your printer, let the software that you are printing from handle the colour management.

What you are aiming for is the image that you have perfected on your monitor to be as near a match as possible on your paper. It can be a bit trial and error. Bear in mind an image viewed on a screen is backlit and illuminated, which is why we are so often disappointed with a quick, cheap, flat print.

Printing processes

Giclee printing is really just a posh name for inkjet printing. A high-pressure pump directs liquid ink from a reservoir through a gun body and a microscopic nozzle, creating a continuous stream of ink to the paper. If you have a photo quality printer it is more than likely an inkjet.

A true photographic print is usually referred to as a C-type, that is chromogenic printing. Conventionally this would have been a colour negative or slide projected onto a light sensitive colour paper, using a wet chemical process. Now a digital C-type is much the same thing, using RGB (red, green and blue) laser to expose the image, with the same final wet process. Digital printing is fast and cheap, and now very popular for printing books and albums. There are many online services, but the quality is not going to be as good as an individually assessed traditional photographic print or Giclee.

To ensure a correct rendition of your image, the correct print profile must be used. Different paper types will require different print profiles. There are numerous weights (thicknesses) and finishes of paper available.

work flow

I am betting that for many busy girls out there your computer has taken over the management of your image downloads and storage, and you don't really have a clear idea of where things are.

Depending on how your computer is set up, your image editing application will spontaneously open and give you the option to download the images automatically for you. However, to begin with I recommend that you manually copy your files into a designated folder structure. This way *you* know where your files live and can make choices about how you manage your archive.

folder structure

First things first, develop your filing structure so you can easily access your images. You will need to store all your original master files, as well as different versions, your high-resolution edited copies for print, low-resolution for sharing, black and white and different crops.

Build a simple filing structure within your 'pictures' folder. The top level folder for each shoot should be labelled with the shoot name and date, for example 'Beth in the Park 201013'. Choose a name that you can easily associate with the shoot for easy identification.

Within your shoot folder, create a sub folder called 'Masters', for the original digital files, unchanged and in their original format, RAW or JPEG. Never save over the original file, as you may want to rework the image in the future and will need to work from the unadulterated original.

download

Post shoot, the first step is to download the images. You can do this either directly from your camera, via a USB cable, or by inserting the memory card into a card reader. If an automatic download option appears, remember to cancel it. Manually copy your files to your designated master folder. Avoid clearing the images from your memory card until you are certain that everything is copied safely onto your computer.

the edit

Next each image must be viewed, considered, kept or discarded. Once you have your final edit, you must process all the files. No matter how well you have executed

♥ Never save over the original file, as you may want to rework the image in the future

your exposures, you will need to adjust white balance, colour and contrast, and make your selection for images to be saved as black and white. Sequence, re-number and convert your files ready to print or to share.

Dedicated editing software, such as Lightroom or Aperture, will allow you to view your masters quickly, so you can make your

selections faster. It's a process of elimination. You can delete the rubbish but don't be too hasty to throw away what at first may look useless, you never know what potential they may offer in the future. Only discard the complete no hopers.

When shooting, as you seek the perfect shot, you will be shooting the same composition repeatedly with tweaks. You will therefore have a run of similar images in a 'set', with small but important differences. When editing, work set by set, keeping the best, and working through the entire shoot session. Resist the temptation to skip to the favourites, work slowly and methodically from start to finish. Once you are happy with your final edit, you can start the process.

top tips

* It's tempting to continue shooting until your card is full, but try to get into the habit of downloading for each separate shooting session. That way you will be able to manage and archive as you go along

* Format your card with your camera at the start of each shooting session

process

Many people are unaware that this stage is necessary. With film, labs would process and print, and each frame would be individually adjusted to bring out the best in the image. It is no different with digital files, each image still needs to be processed individually.

Remember that JPEGs will already have a basic process applied by the camera. RAW will have none, this is where the control of shooting RAW really comes into its own. Bear in mind that any processing adjustments you make to your JPEG file will chip away at its final quality, and there will be less colour and tonal information to play with.

Rather than take every image you have selected through a lengthy process, it's a good idea to do a general clean and basic process first. This will bring the overall selection into a similar range and balance, adjusting exposure, contrast and colour parameters. Also you can make some decisions about cropping and choices for colour or black and white.

Whichever image editing application you happen to be using, you will be confronted by a baffling array of tools and controls for processing. Initially only concern yourself with exposure, white balance, highlights and shadows, contrast, saturation and cropping.

There are no set rules as to what order you start in. You will probably want to re-adjust throughout the process, tweaking as you go, and of course it is totally subjective. Ultimately you want your basic process to result in images that look consistent, clean, and well exposed.

re-naming files

Once you are happy that everything is in order and you have your 'final edit' then re-name your files. It's much more manageable and looks cleaner overall to have your shots numbered and in order. Use at least a three digit sequence, for example starting at 001, as this will hold the order. I would also advise re-naming your images in the same way as your top level shoot folder, for example, 'beth_in_the_ park_201013_001', this way you will always know which shoot a particular image has come from, and how to find it. Do not leave any gaps in the name of the image file as this can cause problems, instead use an underscore, as in the example above.

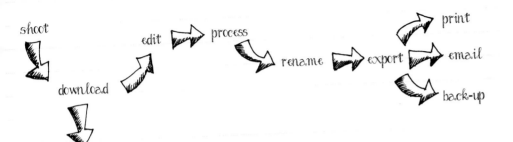

♡ Ultimately you want your basic process to result in images that look consistent, clean, and well exposed

the basic process

1. Adjust your exposure Hopefully you will have got this as near to the mark as possible in camera, but you may want to lighten or darken the overall image. If you are having to make radical adjustments, then something went wrong when you took the shot. You may be able to salvage badly exposed images, but the quality will suffer.

2. White balance You may need to fine-tune the white balance, this will either warm up or cool down the image. It's particularly important to look at people's skin tone. I prefer a cooler palette overall, but you don't want flesh to look cold and washed out.

3. Highlights and shadows This really boils down to fine tuning; detail can be recovered in bright areas of the image using the highlight slider and vice versa with your shadow slider.

4. Contrast in images is usually described as high or low. Low contrast images have little or no highlights or shadows, and are often described as 'flat'. High contrast images are on the other end of the spectrum and will have less information in the mid tones, and appear more dramatic and 'punchy'. If you have shot a particularly 'flat' image, for example a dull day, your image may be improved by increasing the contrast.

5. Saturation This will affect the intensity of the colour. At one end of the scale your image will be in black and white and at the other end you will get some lurid effects. This is the matter of choice, but avoid overcooking it. It's tempting to push the colour for cheap effect.

6. Cropping can make or break an image. Ideally you will have perfected the composition in camera and will only need to crop for a specific aspect ratio. However, there are always occasions when an image can be improved by a little sensitive cropping. Horizons often need to be straightened up. Avoid cropping into an image too heavily as you will radically affect the quality.

eureka!

I refer to images at this first stage as 'viewing files', perfect for general sharing and basic printing. If you are going to select any stand out images for hanging on the wall or publishing, then it's worth taking those files through a final polish, or you may want to try some different treatments, effects and digital manipulation, such as beauty re-touching or removing unwanted elements.

Also most applications offer a range of pre-set treatments such as sepia/aged (think Instagram). These take all the hard work out of the special effect processes, and can give you some ideas and inspiration for taking your image to another level. Tread carefully as some can be a bit heavy handed. You can of course adjust and tone them down.

Don't rule out working with a professional lab to perfect your really special images. Or if you are really enjoying the post-production process, then it's definitely worth learning some more advanced skills and fine tuning your images with a more sophisticated program such as Photoshop.

exporting

If you want to share or print your files you will need to export them from your image editing application. Many applications now link directly with your email or social media accounts making this process very straightforward and convenient. If you wish to print your files however, you will need to export your image as a high-resolution file, at the correct size for your print.

Clicking on the 'export' or 'save as' button in your editing software will bring up a list of options that you will need to understand:

1. Where to save/export the image Select your top level shoot folder and create a sub folder called 'High res'.

2. File naming Do not re-name at this stage as you have done this already.

3. Image format Choose JPEG. At this stage if you have been shooting RAW files we need to convert them so they can be printed. If you have been shooting JPEG, then the format will remain the same.

4. Colour space This should be adobeRGB (1998) for printing. If exporting for web use, you should select sRGB.

5. Quality This will be a slider, or number from 0 – 100, and refers to the amount of compression that will be applied to the JPEG. A low number equals high compression and produces a smaller file. This is good for emailing, however it will reduce the quality of the image. For printing, always set the slider to 100 (least compression) so that you get the best quality print.

6. Export

Metadata is additional information that is stored within an image file. Your camera will record the date and time that the image was taken, as well as camera settings, focal length of the lens, ISO, shutter speed and aperture. This information is a brilliant learning tool, as most software will display these settings alongside your images allowing you to evaluate exactly where you might have gone wrong on images that didn't work, and what you got right on your best images.

Many editing applications will also enable you to add metadata to images, this could be copyright information, or keywords about the image which can be used within a search to identify the image, for example location, subject matter and such like. Metadata is stored within the image, so when you share the image with other people, this information will be shared as well.

Backing up Creating copies of your digital files is essential and should be done regularly so that you do not lose any images or work if something happens to your computer. Using an external hard drive is an easy and quick way to back-up your computer. They are relatively inexpensive and can copy a large amount of information quickly. Most hard drives also come with their own back-up software which will enable you to schedule automatic back-ups. Perfect for the busy girl who has a lot on her mind!

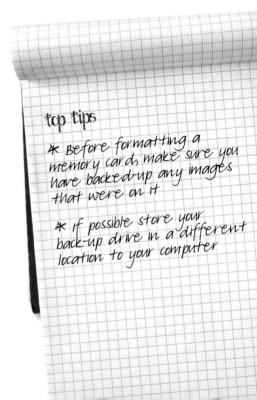

top tips

✳ Before formatting a memory card, make sure you have backed-up any images that were on it

✳ If possible store your back-up drive in a different location to your computer

re-sizing images for email

Your digital camera is capable of taking very high-quality images that are suitable for producing prints. However, for emailing and viewing on screen such high-quality images are not necessary. When viewing solely on screen, file sizes can be greatly reduced without a noticeable difference in quality. To speed up sending time, and to avoid overloading your recipient's mailbox, you should always re-size your images before emailing them.

Your image editor may have a 'web' or 'email' preset which will re-size your images appropriately. If not, the following setting can be used as a general rule for re-sizing:

1. Image size Maintain the aspect ratio, and set the longest side to 800 pixels.
2. Image resolution should be set to 72 dpi.
3. Save the image as a '.jpg' and when prompted set JPEG quality to 10.

These settings should give you a file size of approximately 150k, which will email very quickly and not overload anyone's mailbox!

♥ you should always re-size your images before emailing them

top tip

★ Although social networking sites such as Facebook will re-size your images for you, using the settings above to re-size your shots first will greatly speed up the time it takes to upload your images

 nerdy notes

common file types for images:

jpeg Most digital cameras will shoot in JPEG format and nearly all software will be able to open these files, so they are very easy to share. JPEG is a compressed file format that produces small-sized files, however more compression equals lower image quality.

raw These files contain all the information captured by the camera's sensor. Specialist software is needed to open a RAW file, which then needs to be 'processed' before printing or sharing. RAW files are fairly large, so use up a lot of storage space.

tif commonly used amongst professional photographers and designers for storing images without loss of quality. TIF file sizes are large, using up a lot of storage space.

4: shooting like a pro and making it pay

The mark of a true professional is when every stage of the image making process is mastered, from the composition, exposure and process, through to the print and final presentation. If you are able to execute each stage consistently and prolifically then I would say you have arrived at a professional standard. From starting out as a keen novice to attaining this level will take some time and much practice. Obviously you have to walk before you can run, but the wonderful thing about photography is that you can achieve great images from the get go, and build quickly on your skills, which is why it is universally such an accessible and popular hobby.

Pursuing photography as a semi pro, by taking on a few paying commissions in your spare time, can cover the cost of an expensive hobby, or it may even help supplement your income. Or perhaps you may need to acquire the skill to promote your business or activity without having to invest in a professional photographic service.

In this next section we look at what you need to consider if you want to take your hobby to the next level and make it pay.

If you want to pursue photography professionally, then you will need to learn how to be a good business-person as well as a good photographer. There is a cost involved in getting it right as well as a moral obligation to deliver.

Like most things in life it looks easy from the outside until you try but, unlike a lot of start-up businesses, for relatively little outlay you can set yourself up in a small way. And with hard work, skill and determination you can establish yourself in your own business.

Taking pictures will take up maybe twenty-five per cent of your time if you're lucky. The rest of your time will be spent making sure the work is coming in, and a great deal used in process and post-production. Now, there are many different ways to build your business model: you could outsource a lot of work, or bring everything in house and do every stage yourself. All of the options will need to be explored before you hand in your notice at your regular workplace.

LARGE GROUP OF GIRLS ON A BEACH

It is worth investing some time and money on a good course. Not only will this give you some technical confidence, its nice to make contact with other keen photographers who you can share knowledge and ideas with.

80mm f4 1000th sec ISO 400

setting yourself up

First and foremost, having established that you enjoy it and are technically competent, before you do anything else you must do your market research. Who are the other photographers in your area? There will be lots; photography is one of the world's most popular hobbies, and the market place is crowded with a lot of competition.

Whose work do you like? Why do you like it? How are they presenting themselves? What are they charging and what information are they giving out? What are they offering? Do they have fixed packages and prices? What products and print types are they offering? What market place are they appealing to: budget, mid or high end?

Don't be intimidated, everyone has to do their first job. Your research should inspire you and give you some great ideas to bring into your own profile as a photographer, and hopefully it should pinpoint for you what you are going to offer and to what market.

Having done your market research, you will have a much stronger idea about the direction you will take. You must now try to develop a price for your service. This is difficult; markets change, recession bites, competition increases. I am now competing in a market where there are many people looking to enter into this field professionally, and there are many people offering unbelievably great deals to the customer. I can't see how it is possible to make some of these bargain offers pay, but to break into the market you sometimes have to be prepared to give a lot for little return at first. I can't compete on those terms as I now have a business with premises overheads and salaries to meet; and I value my work, experience and high-end service at a premium.

Bear in mind that after your start-up costs for the equipment, you will incur other running costs. On the most basic level these will be a business card, a web presence, insurance and travel expenses, and printing. These costs will need to be factored in, along with your hours. You must consider this when establishing your rates, but inevitably you can only charge what the market will stand, given your position in it.

Give yourself the edge over others by asking yourself what is your USP: your 'unique selling point'? This could be something as simple as sourcing an unusual or hand made frame to include in a portrait package, or it could be an area of specialization. Whatever you decide, you will need to set yourself apart and stand out from the pack. When it comes to the client making a decision between you and the other photographer it may be something as simple as this that bags you the commission.

getting yourself seen

You can, with the right skills and a few good shots, produce a sexy looking brochure, cool advertizing, and a slick and cleverly designed website. Most photographers can come up with enough 'money shots' for that, but most savvy customers will want to scratch beneath the surface, dig a little deeper and see a wide and varied selection, to feel confident enough to book. I appreciate that

♥ Never undertake a commission unless you feel confident to deliver

when you first start out that it's going to be difficult if you can only put a small selection together. My advice is don't pretend that you have covered hundreds of jobs, be honest, start small and build up your portfolio and rates gradually.

Your portfolio is obviously an essential sales tool, but you will also need to look at other ways of marketing your services. Have a budget in mind: marketing can be very expensive. Unless you are lucky and have a very large start-up fund, you will need to be very careful where you invest your money.

Brochures and websites are expensive, but I would say that you definitely need to have a web presence to compete realistically in today's market, even if it is just a few well laid out pages, with just a small selection of images and words, and some contact details. Social media is also a fantastic way to promote your work, and building followers and 'likes' is important.

Display advertising in the press is expensive. It pays to try and offer something to your regional press, a few really good shots, for them to use in their editorials. You might be able to pay for a very small advert initially, on the condition that one of your shots gets used in the magazine and includes your credit. If you do this, make sure your logo and advert is well designed, clear and punchy. Don't try and cram every shot you have into a credit card size advertisement, it will get lost on the page. Again look at what is out there and what has caught your eye, and emulate it. You will need to develop a style and identity that will become recognizable as yours. This is good business practice. If you are starting

out, then send out a press release. You can't afford to hide your light under a bushel, as the saying goes. The best and most effective advertizing you will get is not paid for, it is word of mouth. If you work well this will come with time, as will discussed editorial though you can't always rely on getting this, and may have to pay for space.

From the outside, photography seems like a great career idea – doing what you love and making money at it as well! Certainly, when you look at what some people charge, it can seem like an unbelievably lucrative job. But consider this: for an average job you may only be shooting for four hours, but with the consultations, calls, reconnaissance taking up to two or three more hours, and post-production viewings and finished collections taking a further six hours, you then start to see the long hours involved. When adding

give yourself the edge over the others by asking yourself what is your USP: your 'unique selling point'?

the expensive outlay, the pressure of the responsibility and the highly competitive arena, it may not seem like such a dream job.

I don't say this to put you off, it can be a fantastically rewarding and creative way of earning a living, but don't be under any false illusions about what is involved. On the following pages you can read about some of the people who started out as busy girls and made the leap to successful professional photographers.

case study: Lemon Zebra

www.lemonzebra.co.uk

Lemon Zebra specializes in 'school photography', which is not exactly top of the glamorous list in the photographic world! However, it suits the lifestyles of Julia Ancliff and Sue Young, who have great fun, and actually run a profitable business. Who needs models, make-up, and high-end fashion? They spend their days with tissues, cuddly toys, rugby balls and books, but they generally work during term time and within school hours, and have created their own local business.

what is your aim?

We try to be as creative as we can within the time limits of a busy school day. Our job is to create images that parents want to buy, and that schools feel proud to offer. Our greatest strength is that we offer a small number of schools within our locality a very bespoke service. Providing we do a good job, we can then enjoy the benefit of repeat business year on year. This enables us to predict our turnover for each season. Having this regular income also allows us to use less busy times to experiment with, and enjoy the more artistic sides of photography.

how did you come up with the idea?

The idea for starting a school photography business evolved during a chat in a taxi whilst on holiday in Majorca. We both had marketing and publicity careers before having kids (we have five children between us), and had a mutual love of photography. By that I mean we both carried cameras with us at all times and had similar ideas about what we liked creatively.

The idea was the easy part. Setting up a business was another matter. Over a curry one night we came up with our company name, Lemon Zebra, to reflect a bright, fresh and contemporary approach, and be something the children might remember.

Then we needed a company logo, partnership agreement, website, insurance, equipment, research, training, practice sessions, suppliers, pricing and portfolio… not quite so painful with two of us, plus a keen sense of humour.

how did you start out?

It was about nine months before we took on our first job. Luckily a friend with a job as a school secretary gave us a chance to try things out (she was very brave!). On the job we worked well together: one of us was responsible for the lighting and photography, the other for the planning and organization of the shoot. Again, after the shoot, one of us edited images and the other sorted out what to do with them. Schools need thorough

♥ we'll carry on as long as it's fun, lucrative and we can still get up from kneeling down!

organization – not only do they want great photos, but they want them in record time and with a fully compatible data disc to work with their software system!

how did you build the business?

One job led to another, and through recommendation, word of mouth and a lot of hard work we have developed a portfolio of schools in the local area. We know them all well and enjoy our regular contact with them – either taking portraits of the children

and staff, or group shots of sports teams, classes, drama productions, prom nights and such like. We feel that

working as a pair and both being mothers is a definite advantage. We have a gentle approach with the nursery children and equally can just about keep up with the teenage banter!

Speed is everything, and is essential to our success. We often have less than 30 seconds per child to take a portrait, and regularly have to finish photographing a whole school by lunchtime. Luckily we have several friends who are happy to help on the shoots, and with the editing and order processing.

what advice would you give to aspiring school photographers?

We always try to keep perspective and a sense of humour. It's important that the schools feel comfortable working with us and that the children enjoy the experience. After that the photographs have to speak for themselves, after all no one has to buy them (but luckily, so far, they have)!

our top tips

1) Find an area of photography that you are interested in but more importantly an area that fits in with your lifestyle.

2) Make sure you know your customers and what they want. We have a two-tier customer base: the schools themselves and then the parents. We juggle the demands and time-restrictions of the schools with the desire of the parents for natural and creative images.

3) And lastly, make sure you find the right technology to run your business successfully. Creating great images is only one half of the battle, the other is to offer them to the market efficiently.

Kelly Green is the busy girl behind the lens at Lola Rose Photography, based near Windsor in Berkshire. She describes herself as a fun-loving, creative photographer who counts herself lucky to be asked to photograph beautiful weddings for amazing couples. Her aim is to capture the love, laughter and emotion, and the little moments, that all add up to the perfect recipe for a wedding day.

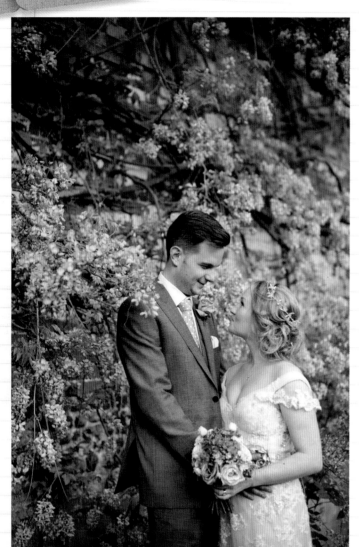

what inspires you?

I am inspired by love, life, family and the essence of what makes us uniquely *us*, hopefully capturing fleeting moments of that with my camera and creating beautiful images that will tell stories for years to come.

how did you start out?

I kind of fell into photography, or rather photography found me. Either way, photographs have always inspired me to see the beauty in the everyday world around us, and to not overlook the little things.

Growing up I was always drawn to old family photos, they captivated me. I was always the one who was passed the camera at family gatherings. 'You have the eye for it', my Mum would often say. So it just seemed natural to always have a camera in my hands.

I really became interested in wedding photography when planning my own wedding.

Then when my best friend got married I took along my old film SLR camera (Canon 300) and snapped away in the background, capturing little moments that may otherwise have been forgotten, whilst they were having the official portraits taken by their photographer. I put together an album as a wedding gift, and they were overjoyed with the relaxed, natural photos I had taken. I completely fell in love with the idea of capturing weddings that day. I had well and truly caught the bug, and began wondering if this could maybe be the start of something new.

Up until this point I had been working as a graphic designer, but after having my two children, Daisy and Lola, I decided to take some time out to be a full time Mum. I invested in a digital SLR (a Canon 40D), began shooting in aperture priority mode and discovered my love of prime

lenses. My photographic style started to emerge and I was finally producing the look that I wanted in my images.

I continued to push forward by teaching myself how to shoot manually, and played with ISO, aperture and shutter speed until I understood how each of them affected my image. I spent hours looking at other wedding photographer's blogs and read about their journeys into the wedding photography industry, which finally gave me the encouragement I needed to build my website and see if I had what it takes.

what was it like to turn professional?

It was scary putting myself out there, I have doubts all the time – am I good enough, can I do this? I slowly started to get bookings and from each wedding I shot, more referrals came in. My business blossomed, and I now shoot an average of 15–20 weddings per year. I continue to push myself creatively, and I learn something new with every wedding I shoot. I don't think you are ever done with learning when it comes to photography.

I put one hundred per cent of myself into what I do, because I love it and it doesn't *feel* like work. My couples become my friends, and I get to capture their memories on one of the best days of their lives. I am so lucky to have a job I love, and I can't imagine ever doing anything else.

> I have to confess to being a bit of a softie and often well up during the speeches, but luckily I can hide behind my camera so no one notices!

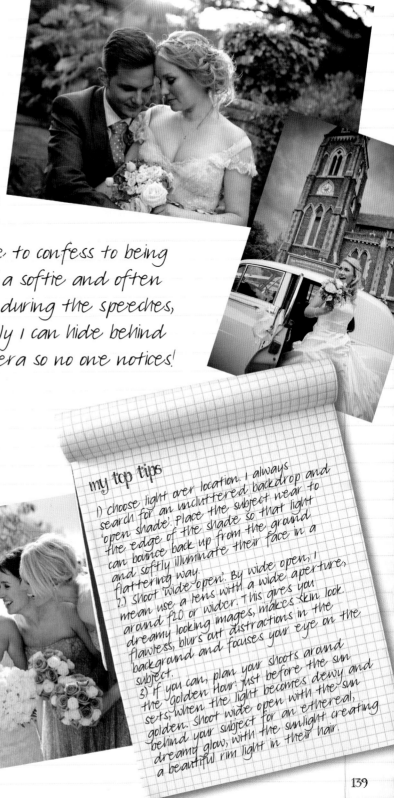

my top tips

1) Choose light over location. I always search for an uncluttered backdrop and 'open shade'. Place the subject near to the edge of the shade so that light can bounce back up from the ground and softly illuminate their face in a flattering way.

2) Shoot 'wide open'. By wide open, I mean use a lens with a wide aperture, around f2.0 or wider. This gives you dreamy looking images, makes skin look flawless, blurs out distractions in the background and focuses your eye on the subject.

3) If you can, plan your shoots around the golden hour, just before the sun sets, when the light becomes dewy and golden. Shoot wide open with the sun behind your subject for an ethereal, dreamy glow, with the sunlight creating a beautiful rim light in their hair.

139

case study:
Rona Wheeldon
www.flowerona.com

A passion for all things floral was the reason behind Rona Wheeldon starting her flower-inspired blog called Flowerona in December 2010. She'd previously retrained as a florist after many years in the corporate world. Then she went on to work for florists in London and Surrey.

Now Rona blogs daily on topics including fresh flowers, florists, wedding flowers, floristry courses and demonstrations, garden flowers, artists and designers… and anything that has a flower on it! Rona's passion for photography has developed since starting Flowerona. In particular, she loves capturing the transient beauty of flowers in all their different forms and colours. Her aim for Flowerona is for it to be a 'feel good' place for people to escape to and be inspired by.

Using social media such as Twitter and Facebook to promote her blog, her readership has grown steadily. As well as writing her own blog, she has also written guest blog posts for Laura Ashley, Sarah Raven's blog Garlic & Sapphire, New Covent Garden Flower Market and Heart Home. And her blog has also been a launch pad for her freelance writing career. She has also written articles for *Wedding Flowers, Perfect Wedding, The Flower Arranger* and *Homemaker* magazines.

how did your interest in photography begin?

Prior to starting Flowerona, I took an online blogging course and became totally fascinated by the photography tutorials. In particular, the way you can take photos where one element in the image is in focus and the background or foreground are blurry. I love the dreamy effect it creates! I realized that with my 'point and click' camera I wasn't going to be able to achieve this look. So the next step was to get a digital SLR camera. And then I decided to take some photography classes to learn how to use it.

what did you struggle with?

I struggled with certain areas within my images being over-exposed, which meant that all the detail was lost, for example, when I was trying to take photos of white flowers. After a one-to-one lesson with Lorna though, I've mastered the manual mode and it's really helped my photographs. It also

took me a little while to get my head around understanding the histograms on my camera.

what have you most enjoyed?

There are several things – from being totally immersed when I'm looking through the viewfinder and composing an image, to seeing the final photograph. And I really appreciate the lovely comments from my readers about my images.

how long has it taken your business to become successful?

The number of people reading Flowerona has grown steadily. I had huge peaks in readership when I wrote about Kate and William's royal wedding, and again when I wrote a series of blog posts about the victory bouquet at the London Olympics 2012. Having reached a good level of traffic to my blog, I now have advertisers and am part of some affiliate schemes.

what advice would you give wannabe busy girl photographers?

My advice would be to attend photography courses to learn how to use your camera. In particular, to understand the relationship between aperture, ISO and shutter speed. I started with a three-day beginner's course (run by an ex-police

♥ ive mastered the manual mode and it's really helped my photographs

photographer with experience in surveillance!), followed by a ten-week intermediate level course, a ten-week course on finding your style and a one-to-one with Lorna. Do appreciate however that there are lots of different ways to take photographs.

my top tips

1) Practise, practise, practise! When I first started attending photography courses, we had homework to complete, and after the course finished I took photos to practise and 'keep my hand in'. I found it really useful to analyze my photos and work out which ones appealed to me and which didn't.

2) Don't just stick with the kit lens that you get with your camera. Buy a prime lens such as a 50mm f/1.8. I love the fact that I can take images with a 1.8 aperture which gives a wonderful blurry effect.

3) Be aware of light, its direction and intensity. It's generally best to avoid bright sunlight but, saying that, sometimes embrace the sunlight and shoot directly towards it. It can give a lovely effect to your images.

lorna yabsley

Lorna, 49, has worked at the 'high end' of the photographic industry for thirty years. Coming into the business at an early age from an arts background, she learned her craft working alongside some of Britain's leading photographers.

Lorna left London and relocated to her native Devon, where she established her studios. Dispelling the tired and staid image of social photography, she pioneered the reportage approach in her bridal work and applied her clean, graphic eye to the commercial field. Her characteristic style has been widely emulated.

In 2008 Lorna established **Bang Wallop** a new brand for photography, including a gallery with shopping and coffee bar, two studios and a training school with eminent guest tutors and exhibitors. As she describes it: 'we are all things photography – a photographic concept store'. As owner and principal photographer of Bang Wallop, she is hands-on in the business: shooting and working closely with her team of photographers, creatives and associates.

Her first book, *Dream Weddings* was published in May 2010.

www.bangwallop.co.uk

www.facebook.com/bangwallopsalcombe

twitter.com/bang_wallop

acknowledgments

This book is for my big wonderful family. With additional thanks to Steve… my rock. And to my team, in particular Jack Kirby who has spent many calm and patient hours working on the Busy Girl with me.

Thanks to all the team at F&W Media, particularly Pru for her brilliant illustrations and bringing the book to life. Finally, thanks to Julia and Sue at Lemon Zebra, Kelly at Lola Rose and Rona of Flowerona for their inspiring case studies.

index

A DAVID & CHARLES BOOK
© F&W Media International, Ltd 2013

David & Charles is an imprint of F&W Media International, Ltd
Brunel House, Forde Close, Newton Abbot, TQ12 4PU, UK

F&W Media International, Ltd is a subsidiary of F+W Media, Inc
10151 Carver Road, Suite #200, Blue Ash, OH 45242, USA

A catalogue record for this book is available from the British Library.

ISBN-13: 978-1-4463-0316-0 paperback
ISBN-10: 1-4463-0316-0 paperback

Printed in China by RR Donnelley for:
F&W Media International, Ltd
Brunel House, Forde Close, Newton Abbot, TQ12 4PU, UK

10 9 8 7 6 5 4 3 2 1

Acquisitions Editor: Judith Harvey
Desk Editor: Hannah Kelly
Project Editor: Jane Trollope
Proofreader: Beth Dymond
Art Editor: Prudence Rogers
Production Manager: Beverley Richardson

F+W Media publishes high quality books on a wide range of subjects.
For more great book ideas visit: www.stitchcraftcreate.co.uk